HISTORIC CRIMES
AND JUSTICE IN
BURLINGTON, VERMONT

HISTORIC CRIMES AND JUSTICE IN BURLINGTON, VERMONT

JEFFREY H. BEERWORTH

Published by The History Press
Charleston, SC 29403
www.historypress.net

Copyright © 2015 by Jeffrey H. Beerworth
All rights reserved

First published 2015

Manufactured in the United States

ISBN 978.1.46711.840.8

Library of Congress Control Number: 2015942275

Notice: The information in this book is true and complete to the best of our knowledge. It is offered without guarantee on the part of the author or The History Press. The author and The History Press disclaim all liability in connection with the use of this book.

All rights reserved. No part of this book may be reproduced or transmitted in any form whatsoever without prior written permission from the publisher except in the case of brief quotations embodied in critical articles and reviews.

Dedicated to the police officers and civilian members of the Burlington Police Department, past and present.

CONTENTS

Foreword, by Chief Michael Schirling	9
Acknowledgements	13
Introduction	15
The Early History of Law Enforcement in Burlington, Vermont	19
An Unruly Place (1865–1869)	25
A Difficult Beginning (1870–1879)	35
Farewell to the Chief (1880–1889)	39
The Pickpocket, a Serial Killer and the Mad Riot (1890–1899)	43
The Death of a Policeman (1900–1909)	55
A Woman in the Ranks (1910–1919)	65
A Tumultuous Decade (1920–1929)	77
At Odds with City Hall (1930–1939)	95
While the World Was at War (1940–1949)	113
The Fire and a Flying Bank Robber (1950–1959)	123
A Terrible Scandal (1960–1969)	133
Murder in the Queen City (1970–1979)	145
Politics, Drugs and Mass Arrests (1980–1989)	157
Recent Decades (1990–2015)	163
Notes	169
Index	185
About the Author	191

FOREWORD

As the Burlington Police Department reaches a milestone in 2015, contemporary policing is often identified by the most visible or written-about tools used by police officers. Police cars, hand-held radios, handcuffs and, most recently, the Taser are among the most identifiable tools associated with modern policing. Cybercrime, global terrorism, "active shooters," domestic and sexual violence, digital evidence and DNA analysis, as well as prescription opiates and designer drugs, are just a few of the things that highlight modern-day challenges. Each year in the twenty-first century, the challenges grow more complex.

Today, technology abounds. Officers carry so much gear that, in 2014, they began wearing load-bearing vests in lieu of the traditional belts to hold all of the contemporary tools of the trade. The law is far more complex. Entire bookcases cannot contain all of the details associated with criminal, motor vehicle and juvenile law—and all of the procedure that goes with it. Today, more than 85 percent of calls for service do not directly relate to crime or criminal investigation. Service responses, ranging from accident investigation to calls to intervene in mental health crises, are the most prevalent events to which officers respond.

Some things have not changed in the 150 years that have elapsed since 1865. Sir Robert Peel, generally thought of as the father of modern policing, authored *Peel's Principles of Modern Law Enforcement*. He wrote these guiding principles in 1829, when he founded the London Metropolitan Police. Each of Peel's principles is enlightening and rings as true today as it did almost

FOREWORD

200 years ago. Here is just one example—his fifth tenet—that resonates as we reach this important milestone:

> *The police seek and preserve public favor, not by catering to public opinion, but by constantly demonstrating absolutely impartial service to the law, in complete independence of policy, and without regard to the justice or injustice of the substance of individual laws; by ready offering of individual service and friendship to all members of society without regard to their race or social standing, by ready exercise of courtesy and friendly good humor; and by ready offering of individual sacrifice in protecting and preserving life.*

What is not effectively captured by Peel—or in the stories of the evolution of the call types, equipment or notable crimes that have littered our history—is the environment in which police officers work. Between organized society and chaos stand a few good people who have chosen one of the most noble professions. While Burlington and Vermont remain among the safest cities and states in the nation, in part because of the 150-year tradition of the Burlington Police Department, there is consistently crime and disorder afoot. As the most visible arm of government, local law enforcement stands at the crossroads of every major social issue in play in our society. Working on a playing field that is moving in three dimensions beneath their feet, police officers, dispatchers and support staff adapt not only year after year but also minute by minute to the challenges with which they are faced.

It is a tough job. And it is equally tough to tell the story of policing on paper. Paper is, most often, emotionless. It so often fails to capture the scope and depth of the work, the effort, the heroism, the tragedy, the humor, the dark times and the resiliency of the human spirit that epitomize the best chapters of the history contained here.

In the two years leading up to the department's 150th anniversary, Detective Jeffrey Beerworth has toiled endlessly over archives, newspaper articles and photographs and in interviews with retired staff to weave together the most comprehensive history of department operations possible. The last twenty years alone represent approximately one million calls for service. This work is a testament to the citizens and businesses, visitors and spectators, crimes and criminals, elected and appointed officials and victims and survivors of crime and tragedy who have most vividly illuminated the human condition in our city for the last century and a half.

FOREWORD

Above all, this compilation of history stands as a monument to hundreds of employees—police officers, dispatchers, parking enforcement personnel and a host of support staff—who have provided public safety and law enforcement services to the Queen City for 54,750 days. These are the stories of service and sacrifice.

Chief Michael Schirling
Burlington Police Department

ACKNOWLEDGEMENTS

With special thanks to:
The Bailey Howe Library
Special Collections, University of Vermont Libraries
The Bixby Memorial Library
The Fletcher Free Library
The Queen City Police Foundation

INTRODUCTION

Today, much like at the department's founding, Burlington police officers are facing increasing challenges in a world that seems to grow more violent. Among these challenges, at times, are public sentiments of distrust and criticism directed at the very nature of policing. The roots of this problem are complex, and both the public and its police officers share a role in its existence. Despite the dedication and courage displayed by members of the force, the perspective of law enforcement is often misunderstood by the people they have sworn to protect.

Police officers are familiar with what is expected of us all, as people and as citizens, and they have experienced the difficulties that life can bring. The burdens and stress that come with a career or unemployment, family problems, relationship issues, financial pressures or the death of a loved one—all can make life a difficult endeavor. Add to these having to deal with the scourges of drug addiction, domestic and sexual abuse and mental illness. Coping with these elements, alone or combined, can be overwhelming.

As for police officers, because of the authority given to them, society requires that they be law abiding, fair and truthful. They must be willing to face injury and, at times, even give their lives for the protection of others. These men and women do not get to choose this danger or the time and place that it will emerge. It can come in the form of a car accident or at the hands of a violent stranger. Officers must be quick to act but flawless in judgment, for each decision they make, in a fraction of a second, will

INTRODUCTION

be criticized from the safety and security of a courtroom. They must be impartial and controlled in their emotions but also kind and sympathetic. If they show leniency, they are called biased; if they enforce the law, they are unjust or power hungry. They face the most devious aspects of human nature and come in contact with people during the worst moments of their lives, and they are expected to emerge unscathed and unaffected. While others are overwhelmed by fear, anger and hatred, officers are expected to be calm and unwavering. They are expected to run toward danger when all others are running away from it. They are preservers of peace but are often labeled as aggressors or militaristic. They are called on to witness horrible acts of violence and depravity and yet still view the people they serve with respect and dignity. They are criticized and even hated by some and are often viewed as intolerant, regardless of their personal creeds. They dedicate their lives to the safety of others but are often viewed as the opposition. Officers carry out their duties in the late night hours of the midnight shift, in the coldest days of winter and without exemption for Thanksgiving dinners and Christmas mornings. Not only are they expected to endure all of these difficulties daily, but they are also expected to perform their duties consistently for the duration of twenty-five years.

Citizens are seldom, if ever, required to consider a police officer's perspective while police officers are citizens and share a citizen's perspective. Often unrecognized behind the uniform and badge is the humanity of the officer. He or she has a family and loved ones and endures all the same stresses that life can bring, in addition to those intrinsic to the policing profession. The oath that officers take does not relieve them of the burdens of their personal lives or make them immune to the weaknesses of human nature. They aspire to and exemplify the best qualities of humanity while still sharing in its weaknesses. These men and women make incredible sacrifices to insulate and protect the innocent from danger. It is a sacrifice deserving of the public's consideration and understanding. More importantly, it is a human endeavor that requires our involvement and support, both in prosperous times and in difficult days.

The history of this police department is also the history of the city and its people. It is my hope that this work will aid in the understanding of this shared human experience and help to bridge the divide that often separates the citizens of Burlington and the officers who have sworn to protect them. For officers, it is an opportunity to understand the mistakes and failures of the past while celebrating the triumphs of those who came before them. For citizens, this history presents a unique look into how law

INTRODUCTION

enforcement has developed over time and outlines many of the challenges that officers face on a daily basis. As readers explore this history, I hope they recognize that this book accounts for a very small portion of the department's overall history. In its entirety, it is a history that speaks to the shared efforts of the officers of the department, its civilian staff, the city of Burlington and its citizens. It is a 150-year-old partnership that has ensured the city's future and fashioned its police department into one of the greatest in New England.

THE EARLY HISTORY OF LAW ENFORCEMENT IN BURLINGTON, VERMONT

The settlement of Burlington was chartered on June 7, 1763, by Benning Wentworth, the colonial governor of New Hampshire. The charter was secured through the efforts of Colonel Thomas Chittenden, who would become the first governor of Vermont. Ira and Ethan Allen were in attendance at the meeting when the charter was approved, and the same Allen brothers would later survey the land that would become the village of Burlington.[1] As land grants were being issued throughout the territory, and as new settlements were taking shape, the Republic of Vermont was born.

In 1777, the Republic of Vermont established its constitution, and in order to fulfill its promise to protect its people and their property, the government appointed constables and sheriffs. This police authority was born of both necessity and trust. Haunted by the brutal raids of the French and Indian War, it was not until 1783 that a lasting settlement took hold along the shores of Lake Champlain.[2] To ensure its peaceful future, the founders of Burlington practiced a simple but strict form of law and order, as harsh as the wilderness they governed.

If a person violated the Sunday Law, the perpetrator was fined three pounds and would be made to sit in the stocks for two hours. Profanity brought a heavy fine for each offense, and the offender was confined to the stocks for three hours. Anyone caught stealing property would have to restore that property threefold and would be given thirty-nine lashes at the whipping post. Treason, murder and arson, if death resulted, were

HISTORIC CRIMES AND JUSTICE IN BURLINGTON, VERMONT

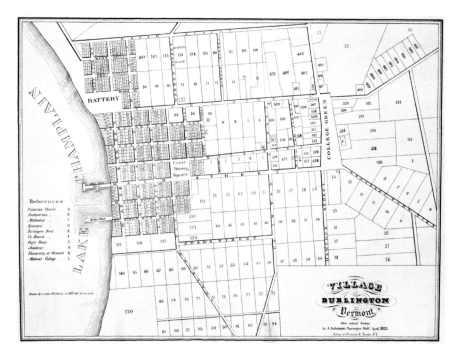

Map of the village of Burlington, 1833. *Special Collections, University of Vermont Libraries.*

punishable by death. Manslaughter and bearing false witness without death resulting were punishable by a term of no less than seven years in the state prison. Assault with intent to rob, forgery, rape or "assault with an intent to know a person" and perjury were punishable by seven years in prison and a fine of $2,000.[3] Bigamy, horse stealing and robbery earned the offender a seven-year prison sentence but brought punishment of life in prison for a second offense. Theft and receiving stolen goods were punishable by a term of no less than seven years. In almost all cases, imprisonment was accompanied by hard labor.[4] These sentences were not necessarily separate from other punitive measures of the day, which included the cutting off of ears, whipping, pillory and branding. In fact, it was state law that each town was to maintain a pair of stocks, affixed with lock and key, for the purpose of criminal punishment.[5]

In March 1791, Vermont joined the United States of America, and in the fall of that year, the legislature made Burlington the shire town of Chittenden County, which it has remained to the present day. The first criminal court in Burlington was held at the inn of Captain Gideon King, located near the intersection of Battery and King Streets.[6] The room used by the court

was approximately sixteen by twenty feet and was presided over by Chief Justice John Fassett Jr.[7] In 1795, the first county courthouse was erected in the area of what is now City Hall Park, followed by the first county jail in 1796. Historical accounts tell of an old pine tree that stood almost eighty feet tall and served as the whipping post. The whipping tree was located just northeast of the present-day fountain in City Hall Park[8] and was cut down in 1830.[9]

A point of added interest was that the keeper of the jail, Mr. King, was also a tavern keeper. When the county jail was erected, not wanting to give up his primary trade, Mr. King had a tavern built attached to the jail so that he could oversee its prisoners while he conducted the business of the tavern. However, when the courthouse was rebuilt in 1802, King was forced to move the tavern elsewhere.[10]

The Chittenden County Jail

The early laws of Vermont often carried a sentence with hard labor, but by the 1830s, a single night within the walls of the Chittenden County Jail was the equivalent of a medieval sentence. By 1838, the jail had been in use for forty-two years and was in a horrible state of disrepair. The jail had experienced an increasing number of prisoner escapes due to the deterioration of its walls and perhaps due to the prisoners' motivation to escape its draconian conditions. In 1838, a panel of grand jurors was sent to the jail to examine and compile a report on the jail's current condition. What they found was horrifying. To begin, the walls were found to be in a concerning state of decay. Secondly, there were no separations for male and female prisoners, and the cells were found to be so dark and damp that they were presumed offensively unhealthy for any occupants. The state of the prison was so poor that the grand jurors questioned the overall humanity of the people of Chittenden County.[11] The report likened the prison to the "darkness and dampness, and impurity of a tomb." The title of the grand jurors' report summarized their feelings: "Punishment before Conviction!"[12]

By 1850, Burlington had become the commercial center of the region, utilizing the lake to transport goods and merchandise to New York and Montreal. It had also developed railway connections to the Atlantic, the Great

Lakes and the St. Lawrence Valley. The population of the town increased at a steady rate, and businesses and residential houses spread throughout the hillsides. By the turn of the century, institutions such as the University of Vermont and the post office were well established. Churches, banks and newspapers began to crop up, enriched by the growing population and nurtured by industry and commerce. The greatest influence on prosperity was the lumber industry. The first shipments of lumber arrived in 1850, and by 1856, lumber trade and commerce had increased by staggering proportions. Within decades, the waterfront was occupied by five large lumber firms, making Burlington one of the leading lumber producers in the United States.[13] These companies would later play a crucial role in the development of the police department by privately hiring special policemen to protect the industry from the threat of fire.

On November 23, 1852, Governor Fairbanks signed a legislative act that created the village of Burlington.[14] One of the provisions of the village charter was the power to authorize the appointments of seven police officers, who would be granted the power to arrest anyone acting against the charter or the bylaws of Burlington.[15]

At the time, the only requirement needed to become a constable, or police officer, was to take an oath to uphold the law and protect the town. These men were given a term of one year, at which time they could be reappointed or replaced. In fulfilling their official duties, "officers were authorized to break open doors and even to kill an alleged offender, if the person could not otherwise be restrained and taken in for questioning."[16]

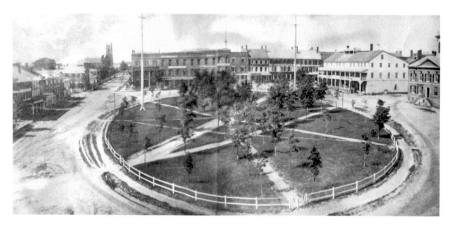

City Hall Park, 1859. *Special Collections, University of Vermont Libraries.*

The system of pay for the officers was primarily based on the number of arrests that they made and would depend on whether the arrest led to a conviction. Furthermore, the amount of pay depended on the fine that was levied against the offender.[17] Essentially, the more serious the crime, the higher the fine—which equated to a higher payment for the arresting officer.

In the early 1850s, attempts were made to incorporate Burlington into a city, but the proposals were met by opposition. Some questioned whether a city government would best serve the people and feared that it would lead to corruption. Supporters argued that an independent city government could provide more services and give the mayor strong administrative and financial control of city affairs.[18] Although the proposal was initially rejected, the rapid growth of the town made a city charter inevitable. A proposal was finally accepted, and in February 1865, a thirteen-mile portion of the village closest to the lake was officially incorporated as a city, boasting a population of 7,500 people.[19]

AN UNRULY PLACE (1865-1869)

While the nation anxiously awaited the end of the Civil War, the Vermont legislature approved the creation of the city of Burlington. The city charter, built on the foundation of the village charter of 1852, called for a more structured organization of city affairs. To ensure its safety and protection, the city established the Burlington Police Department, which was officially organized, along with the city government, on February 21, 1865. The men of the department would be asked to uphold the constitution and abide by the authority given to them by the citizens, under the direction of the first constable, or chief of police.

The charter of 1865 also created a series of new city ordinances, ranging from the regulation of livestock to public safety–related issues. Other ordinances addressed obscene language and indecent gestures, as well as the expected conduct of citizens on the Lord's Day. The city also created an ordinance to govern the licensing of saloons.[20]

During this time, Burlington's economic light was attracting visitors and working families while also luring in "tramps" and criminal characters from around Vermont and the surrounding states. Where there are people, there is crime, and the city would turn to its police department to ensure its optimistic future. The officers of the Burlington Police Department were tasked with enforcing the new ordinances, along with addressing the common crimes of the day, including murder, assault and highway robbery. They did so without uniforms and without issued equipment. In fact, the only visible sign setting them apart from civilians

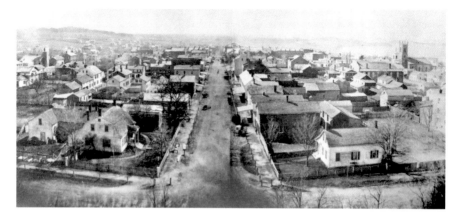

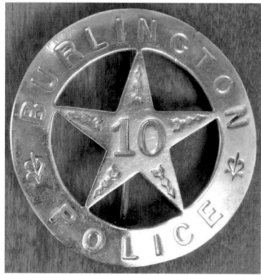

Above: Overview of Burlington, looking south down Church Street from Pearl Street, 1860. *Special Collections, University of Vermont Libraries.*

Left: The oldest known Burlington police badge modeled after a traditional-style sheriff's badge. *The Burlington Police Department.*

was the badge, which mimicked the style of the sheriff's badge: a five-pointed star enclosed in a circle.[21]

The first constable, or chief of police, would supervise and assist the officers of the department in the enforcement and prosecution of any crime or offense against the ordinances of the city. It is also important to understand that the first constable and the men of the department were not just police officers. They were citizens, and they came from a wide range of backgrounds. Some came from more fortunate circumstances and obtained appointments through family ties or political connection, while others were simple laborers, employed on the docks or in the lumberyards of the city. Most held second jobs to supplement their incomes and struggled to

provide for their families. Some men were immigrants; others were longtime Vermonters. Some were educated; others could not read or write. These men were people—fathers, sons and citizens—equal in every way to those they had sworn to protect. Like the lawmen of the West, these brave men served without training and without rules of conduct to guide them, other than the content of their characters. All would endure the dangers of policing and the sleepless hours of the night patrol with the promise of little or no pay. All would feel the pressures of political influence and the demands of their sworn oaths. Some would serve with honor; others would falter.

For many, their appointment as an officer was their only means of upward mobility, and as was often the case at this time in America, their appointment would come at a price. Because these appointments could depend on which politician was in power, police officers were often used as political operatives, engaging in voter intimidation and fraud.[22] These illegitimate practices were common during the era of Reconstruction, and although their extent is unknown, their presence in Burlington during these early years can reasonably be assumed.

In 1865, Albert L. Catlin, the man who referred to Burlington as the "Queen City of New England," approved the commission of Luman A. Drew to be the city's first constable.[23] Drew was officially appointed on June 7, 1865, and immediately assumed the duties of the office.

Drew was born in Burlington on October 27, 1832, and was educated in the city's public schools and at Bakersfield Academy. After graduation, he became an associate in his father's wholesale meat business, to which he would return after his long tenure as county sheriff and chief of police. Along with his local ties, Drew had rendered a more relevant service to the state of Vermont that made him the obvious choice to be first constable. It occurred on October 19, 1864, when a band of Confederate cavalrymen

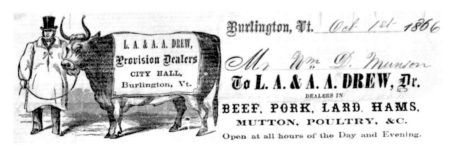

An advertisement for Chief Luman Drew's meat business, 1866. *Special Collections, University of Vermont Libraries.*

raided the town of St. Albans, Vermont. The St. Albans Raid was the northernmost action of the Civil War, in which Rebels robbed local banks of $208,000 and attempted to burn down the town. Drew was serving as a village constable at the time and aided in the pursuit of the Confederates by carrying dispatch communications between the soldiers of St. Albans and army reinforcements in Burlington. Many of the raiders were pursued into Canada and arrested.

The orders given to Drew called for the group of soldiers to invade the British territories in pursuit of the Rebels. Under normal circumstances, this was a violation of law, and if the pursuit was not handled properly, it could have led to war between the United States and the British territories. Drew's mission was handled discreetly and without national incident.[24] His service was deemed meritorious by Colonel Conger, and in February 1865, he was appointed by Governor Smith to be quartermaster in the Second Regiment.[25]

In 1865, the police department consisted of Drew and five regular patrolmen whose primary duties were given to the prevention of crime and the arrest of criminal suspects. The officers were also tasked with lighting the gas street lamps at dusk and extinguishing them at a reasonably safe hour. At the request of the mayor, the department also assisted with the removal of garbage, dirt and refuse from city streets.[26]

In its first year, the police department suffered many growing pains as it worked to fulfill the requirements of its charter with limited resources. At the close of 1865, the department had made 248 arrests, 90 percent of which were liquor-related offenses. In addition, there were three incidents of highway robbery, indicating that the city could be an unruly place.[27] There were thirty-one arrests for prostitution, validating the creation of a new ordinance against "Common Prostitutes."[28] However, Chief Drew noted that at the end of the Civil War, with the discharging of soldiers from army forts and hospitals, the occurrences of prostitution seemed to diminish.[29] In need of a more proactive approach, two additional officers were added to the force, designated with the title of detective, or secret police. They were tasked with addressing all suspicious people arriving, "by land or water," and keeping watch over them. They also paid special attention to "idlers" and "loungers," who could be arrested for vagrancy.[30]

The Griswold Murder Case

The Griswold case is perhaps the most famous murder case in the state's early history, and although it occurred in the town of Williston, deputy U.S. marshal Noble B. Flanagan, who was also a Burlington Police officer, played a key role in its outcome. The notoriety that he would gain from its resolution would propel him to the office of chief of police in 1868.

It all began on August 27, 1865, and involved the Griswold family, consisting of Mrs. Sally Griswold, her husband, their young son, their daughter and their son-in-law, Charles Potter. It was on that day that the entire family, except for Mrs. Sally Griswold and her young son, left on a trip to Canada. On the following Sunday, a neighbor went to check on Mrs. Griswold and found a horrific sight. The young Griswold boy was found locked in his bedroom, screaming for help, while Mrs. Griswold's body was found in a calf pen near the barn. Her throat had been cut from ear to ear.[31]

The next morning, along the road to Burlington, before news of the murder had reached the city, a stranger by the name of John Ward approached George W. Kelley, an express messenger, for a ride to New York. Being a gentleman, Kelley agreed to take Ward on board. During the journey, Kelley noticed that Ward's clothes were bloodstained and heavily soiled, and when asked, Ward told him a tale of how he had been in a tavern brawl the night before. With no reason to doubt his fellow traveler, Kelley proceeded to New York.[32]

Once news of the murder reached the city, deputy U.S. marshal Noble B. Flanagan was assigned to investigate the case on behalf of the citizens of Williston. Upon his return, having learned of the murder, Kelley notified the authorities about the stranger he had met with bloodstained clothing. After obtaining a detailed physical description of Ward, Flanagan headed across Lake Champlain to New York. The lawman was in the city for only a few days when he happened upon Ward on the street. Not having jurisdiction in New York, Flanagan followed Ward for several days, until the man happened to make his way back to Vermont, boarding a train in Charlotte. When the train reached Burlington, fearing that he was being followed, Ward rushed out onto the train platform and hid behind a stack of lumber. When his fears subsided, Ward again boarded the train and fatefully walked into the same car in which Flanagan was waiting for him. As the train pulled into the Winooski Depot, Flanagan seized Ward by the collar, jumped off the train and placed him under arrest.[33]

Three days later, Charles Potter was also arrested in connection with the murder. It was Flanagan's belief that Potter had hired Ward to murder

his mother-in-law, knowing that his wife, Adelia S. Potter, was Griswold's designated heir. Unknown to many, Mrs. Griswold had owned property in California worth over $10,000.[34]

The trial of Ward and Potter was presided over by the Honorable Judge William H. French and would bring to light the gruesome nature of the murder. State's Attorney Englesby opened the trial by presenting the jury with a drawing of Griswold's house and land and proceeded to outline the circumstances of the murder. Englesby presented the jury with the fact that Ward had told a witness that he was involved in a tavern fight in which he used a revolver and a billy club. Englesby also pointed out that when arrested, Ward was found to be in possession of a revolver, a billy club, a vial of chloroform and an eye patch.[35]

The first witness called in the case was Morris Sullivan, the first person to arrive at the Griswold house after the killing. As he approached the house, Sullivan heard the young Griswold boy calling for help. He rushed into the house and found that a stick had been pushed into the latch on the bedroom door. After freeing the boy, Sullivan began searching the house for Mrs. Griswold, but she was nowhere to be found. One of the neighbors, Mr. Fox, then checked the calf stable and found Mrs. Griswold's body partially wrapped in old bed quilts. Sullivan also testified that Charles Potter and Mrs. Griswold were not on friendly terms. He reported that in the days prior to the murder, he had seen a stranger talking with Potter. Sullivan described the stranger but could not remember whether he had chin whiskers or not. Although the overall description matched that of Ward, Sullivan was unable to positively identify him as the stranger who had met with Potter.

The trial continued into the afternoon as William Taft testified to examining the scene and measuring the bloody footprints in the interior of the residence. Inside the bedroom, the drawers were found to have been rummaged through, and a pair of bloody socks was found on the floor. Another witness testified to seeing two sets of footprints in the residence, indicating that two men may have committed the crime.

The following witness was Mary Sullivan. She testified that a man came to meet with Mrs. Griswold the week before the murder, inquiring about buying several horses from her. Mrs. Sullivan described the man as having a light complexion, black chin whiskers and a moustache. She also identified Ward as the man who had met with Mrs. Griswold that afternoon. Upon cross-examination, the defense pointed out that Ward did not currently have any chin whiskers and instead had a thin moustache. It was also pointed out that Ward was dressed very differently than the man Mrs. Sullivan had described.

The next witness called was Dr. Sprague, the man who examined Griswold's body. He confirmed that her body was found partially wrapped in blankets near the calf stable. Upon unwrapping the blankets, he found several cuts on Mrs. Griswold's throat and face and three contusions on the left side of her head. Dr. Sprague noted that one of the cuts to her throat had severed the external jugular vein on the right side.

State's Attorney Englesby then presented a knife that was found in the residence, and the witness confirmed that the blade matched one of the cuts found on Griswold's chin. Englesby also presented Dr. Sprauge with Ward's billy club, and he confirmed that the club could have induced the injuries to Mrs. Griswold's head.

Another witness, George Williams, testified that Potter had once told Williams, "God has got a devil, but not so great a one as he had," referring to his mother-in-law, Mrs. Griswold.[36] Later that afternoon, George W. Kelley testified before the court. Kelley explained how Ward had been a passenger in his cart and advised that as they were passing through New Haven, Ward told him about being attacked by three men the day before somewhere in Burlington. Ward told him that he had fired his revolver at his attackers and was not sure if he hurt them. Kelley confirmed that the Smith & Wesson revolver with which Ward had been arrested looked very much like the revolver he was shown. Ward also told Kelley that he used a billy club to fight off his assailants and that he struck one of them in the head. Kelley testified to seeing Ward's clothing covered in blood and stated that Ward himself had said that the fight had been a bloody one. Kelley then positively identified John Ward as the man who rode with him to New York on the day of the murder.[37]

When the trial resumed on April 11, deputy U.S. marshal Noble B. Flanagan was called to take the stand. Flanagan told the court that he first saw John Ward on Chamber Street, between Broadway and West Broadway in New York, and found him to match the description of Kelley's passenger. Flanagan testified that on the train back to Burlington, he observed Ward pulling his wide-brimmed hat down over his eyes and raising a handkerchief over his mouth in an attempt to hide his face. Upon his arrest, Ward was escorted to a tavern in Winooski, where Flanagan conducted a search of his person. In his pocket was a loaded revolver. In his waistband, Flanagan found a billy club, and in his vest pocket was an eye patch. Flanagan also found a four-ounce vial of chloroform that Ward claimed to be using for a toothache.[38]

Dr. Atwatke testified on the effects of chloroform and told the court that chloroform could be used to treat a toothache; however, its primary purpose

was to cause insensibility and could render a person unconscious if applied to the nose and mouth.[39]

After closing arguments were made by the defense and prosecution, the jury handed down its verdict. John Ward was found guilty and sentenced to death for the murder of Mrs. Sally Griswold. Although it was widely believed that Charles Potter had hired Ward to kill Mrs. Griswold, his connection could not be proven, and he was found not guilty. Ward's case was appealed to the Supreme Court in 1867, but the higher court upheld the conviction.

Ward's execution was held on March 29, 1868, at the state prison in Windsor, Vermont. The night before, Ward had spoken at length with Reverend Butler, the chaplain of the prison, and he wrote several letters in the early morning hours. Through those conversations and letters, Ward made three confessions, most of which were later discredited. In his third and final confession, Ward admitted to being present at the murder but claimed that a man named "Moore" had committed the killing. Ward also confessed to holding Mrs. Griswold while Moore cut her throat. At thirteen minutes past one o'clock in the afternoon, Ward was escorted to the scaffolding in the Windsor State Prison yard. He was accompanied by many law enforcement officials and Reverend Butler. Also in attendance was the man who brought Ward to justice, Noble B. Flanagan. Before his death sentence was carried out, Ward spoke with Flanagan, saying:

> *Flanagan the time has been when my feelings against you were so bitter that I would if possible have killed you. All that feeling is gone now, and I feel no resentment towards you, knowing that you have only done your duty well. I only wish to warn you, however, to be on your guard, as there are men still on your track to do you mischief. At the time of my trial a thousand dollars was offered for your life, and at that time you were followed and watched, and by the nearest chance escaped on one occasion, when some roughs were watching for you at the Station House.*[40]

Ward then respectfully shook Flanagan's hand, and the two men bid each other farewell. At the prisoner's request, two six-inch boxes were fastened to the drop hatch so that his death might be more swift.[41]

IN APRIL 1866, a new mayor was elected, Torrey E. Wales. Wales was a Vermonter from humble beginnings who attended the University of Vermont and later became a prominent lawyer in Burlington. He was elected state's attorney in 1853 and held the office for three consecutive years. Wales was

Luman Drew's appointment as chief of police, 1868. *Special Collections, University of Vermont Libraries.*

later made a probate judge in 1862. Wales also served in the Howard Guard of the Burlington Militia, an assignment that exemplified his concern for public safety.[42] When he came into office, he found the department understaffed and desperately underfunded. The city had left the police department with an annual budget of $500, and despite the additional $111 collected from making arrests, the budget was still far less than in the previous year.[43]

In April 1867, the department expanded its ranks to twelve officers, losing one to resignation and another to bilious fever. On January 6, 1868, Noble Flanagan was appointed chief of police and served as such until April, when the reins were once again handed to Luman Drew. In that year, the department paid special attention to the thirty-four "diving bells" that had cropped up in the city.[44] These secret saloons were fake storefronts, offering tobacco and pipes or various fruits and potatoes in order to mask the sale of liquor.[45] The diving bells got their name due to their common function. Patrons would be inside enjoying illegal liquor while a lookout was posted outside the establishment. When a police officer approached, the lookout would ring a bell, and those inside would dive out the back.[46]

$100 REWARD!

Stop Thief.

Stolen from the stable of the subscriber, on the night of the 8th inst., a light colored sorrel MARE, 6 years old, with long tail, star in forehead, scar on left knee, one white fore foot, stands 15 1-2 hands high, good style, and weighs about 1050 lbs. Also, a Pung Sleigh, red top, striped black and white, yellow bottom, with black stripe, and back of seat broken. Silver mounted breastplate Harness, whole reins with russet leather ends. A very nice large lined Buffalo robe, and a horse Blanket.

$50 will be paid for the property, a[nd] $50 for the arrest and conviction of t[he] thief. Information may be left wi[th] W. B. PATTEN, City Marshal, Manchester, N. H.

JOHN WEST.

Francestown, N. H., Jan. 9, 1868.

A reward poster sent to Burlington from Marshal John West of Francestown, New Hampshire, 1868. *Special Collections, University of Vermont Libraries.*

In 1868, the ranks of the department swelled to eighteen, and for the first time noted in city records, the officers were issued police badges.[47] Chief Drew's appointment expired in April 1869, and Noble Flanagan was once again appointed chief under the newly elected mayor, Phineas D. Ballou.

A DIFFICULT BEGINNING (1870-1879)

On October 6, 1870, after only a few months in office, Mayor D.C. Linsley resigned. The former mayor, Torrey E. Wales, filled in as acting mayor until the term expired, but the city had other troubles besides the resignation of its mayor. The year saw a marked rise in crime, resulting in 610 arrests. Chief Flanagan had thirty-three officers at his disposal; however, twenty-two were under the employment of the lumberyards, leaving only eleven to tend to the needs of the city. Never one to hold back, Flanagan openly criticized the men in his ranks, stating that of the eleven officers, only half would reliably report for their patrols. In addition to its internal challenges, the city was being plagued by a mischievous group of young men who would fight and wreak havoc into the late hours of the night.[48] Flanagan urged the city to construct a workhouse so that convicts of such offenses could be put to work for the benefit of the city. Flanagan also criticized the criminal justice system, believing that it was not serving its intended purpose. To resolve the issue, Flanagan recommended purchasing a lot near the stone quarry, where stone could be procured free of charge and offenders of petty crimes could work to break the stones into a suitable size to coat the streets of the city.[49]

Chief Flanagan left office in 1872, and although the reason for his departure is uncertain, there was no question about the abilities of the man picked to replace him. Luman Drew was once again appointed chief, and with his return to the basement office of city hall, the department experienced a visible change, one that is taken for granted today. The department became uniformed. Of the twenty-six regular patrolmen, eighteen were given

police uniforms through funds provided by the city council and a donation from the Merchant's National Bank. The uniforms greatly improved the overall feeling of protection in the city and the visibility of its policemen. Drew stated that the "stranger within our gates" can more easily identify a policeman and receive assistance when needed.[50] The chief's annual report for that year also noted that seventy-eight homeless people had found shelter and a bed in the police station over the past year—a common charitable practice in those early years.

In 1873, the mayor insisted that a special daytime patrol, consisting of four officers, be maintained despite a reduction in manpower. In order to ensure efficiency, a new element was added to the night patrol duties of the police department. At the chief's request, the Merchants National Bank purchased a "Tell-Tale Clock."[51] This new clock was a welcomed innovation for the faithful officers of the department and would become the dread of those who neglected their duties. The clock required that a night patrolman wind it once every hour or else his failure to do so would be recorded. This allowed the chief of police to ensure that the officers were conducting proper patrols at a time when the department was bearing the difficult demands of a growing city. It was also in that year that Chief Drew asked the city aldermen to formulate rules and regulations for the conduct of his officers, but his request went unanswered.

In 1874, Calvin H. Blodgett was elected mayor, and he focused heavily on cost-cutting measures for all city departments. Despite Blodgett's financial concerns, on June 15, 1874, the city approved a proposal in which policemen assigned to the night patrol would be paid two dollars per night. The vote included the pay of one dollar per night for officers working the night patrol at the train depot, the wharf and on Battery Street. Therefore, four of the twenty-five police officers began receiving pay for their services. The department also received eight new uniforms that year, but due to the actions of city hall, the patrolmen were made to pay for half the costs. The eight uniforms, by necessity, were shared among the officers.[52]

In 1876, under substantial municipal debt, Burlington elected a new mayor, Jo D. Hatch. To his credit and, later, esteem, Hatch did not swing a blind axe and held a much different perspective than his predecessors in his opinions of the police department. He recognized that the department was not a revenue-producing entity and that it was unfair to expect the department to turn a profit or even balance its expenses. In an effort to avoid attrition, Hatch adopted a policy in which the city would fight only

criminal and civil cases that it could win in an attempt to reduce court costs. Despite his fiscal efforts, the number of regular police officers was reduced to eight.[53]

Chief Drew was deeply concerned that the city had outgrown its police department. For fifteen years, the city had failed to recognize the need to invest in the department and steadily reduced its resources. In an address to the mayor, Drew laid out clear statistics regarding the comparative finances of the police department and the need for a change in course. Drew compared the city of Burlington, with a population of 14,387, with other small cities. The city of Portland, with a population of 20,000, had an annual police department expense of $27,961.80. Salem, Massachusetts, with a population of 22,000, had an annual expense of $33,965.21. In contrast, the total expenses of the Burlington Police department were $2,265.50.[54] The disparity was startling, but the department would have to make do until the finances of the city could be restored.

Amidst the financial turmoil of 1876, a noteworthy historical event occurred. Although the exact terms might never be known, the records for the department indicate that a sum of money was paid to Eli Pouquette for an "informer's complaint."[55] This is the earliest record of the police department compensating a citizen for providing information on criminal activity. Although the idea of confidentiality in regards to informants was nearly a century away, the records indicate that a sum of five dollars was paid for the information provided. The transaction was most likely connected with the operation of an illegal saloon or the illegal sale of liquor.

In 1877, drawing from Chief Drew's financial presentation of the year before, Mayor Hatch highlighted the fact that most smaller cities in New England with populations of ten thousand to thirty thousand inhabitants had a police expense of $1.00 to $1.50 per capita, while Burlington had an expense of $0.15 per capita. In an act of political mastery, Hatch credited the feat to the "efficiency of the police" and the "order-loving, law-abiding character" of the citizens of Burlington.[56] The simple truth was that the department was understaffed and underpaid.

In 1879, Chief Drew added special foot patrols to cover St. Joseph's Cathedral and the Gas Works Department. It was also in that year that the department acquired an unanticipated ally. A telephone was added to the station house, freeing up a patrolman who had been previously assigned to the basement office at city hall.[57]

To close out the decade, Chief Drew congratulated his officers for their efforts during the past year and gave specific attention to a successful raid

on a house of ill repute. He also directed special thanks to the Vermont legislature for the establishment of the house of correction. Drew described the jail as a "well managed institution and a terror to evil-doers, which jail or fines had failed to be."[58]

FAREWELL TO THE CHIEF (1880-1889)

In 1881, the department contended with crimes of murder, burglary, prostitution, vagrancy and liquor-related offenses. Under Chief Drew's continued command, the department executed sixty search warrants that year, which was a considerable number given that the department consisted of just six regular policemen.[59]

By 1882, Mayor Hatch had presided over one of the greatest financial turnarounds the city had ever seen. He had become one of the department's greatest supporters and established a lasting friendship with Chief Drew, but that year would be his last in office. It was also the year that Chief Drew resigned. Drew had served the city for the better part of two decades, as both county sheriff and chief of police. He had labored through the difficulties of each new administration and the law enforcement challenges of each new year. At the age of fifty, tired of city politics and the dangers of policing, he withdrew from office. Although his civilian life as a businessman was long and fruitful, he would look back fondly on his years as a policeman. In fact, in 1898, after sixteen years of civilian life, the old lawman would once again take up the badge, this time as a deputy United States marshal for the district of Vermont. He did so at the age of sixty-six, and in 1902, at the age of seventy, Drew made an extended trip to California, charged with the transportation and deportation of twenty-three Chinese immigrants.[60]

The department had bid farewell to its leader, but 1882 would not end without further loss. On December 22, Noble B. Flanagan, a former chief of police, died of a stomach ailment at the age of seventy.[61]

In 1883, the head office at city hall was passed to George H. Morse, who appointed Joseph Barton to be the next chief of police. Keeping with tradition, Barton also served as sheriff of Chittenden County. A measure of his character, and his fundamental understanding of the men under his command, can be found in the words he presented that year:

> *Few people unless they have taken pains to study the life of a policeman have the remotest idea of what is expected of him or the hardships and dangers he has to undergo night and day. He is expected to patrol the streets and be found at his post of duty whether in rain, hail, or sunshine. Not only is he expected to care for the lives and property of citizens while they sleep, but he must be present at all times and on all occasions. He must be present at every fire; must be present to preserve peace at large gatherings, entertainments and such like. He is expected always to be able to enlighten you in regard to persons as well as places. He must be an escort for processions. He must look after violations of the City Ordinances and an infinite range of other work the extent of which the public have little idea. People generally expect more from a policeman than they reasonably should. And they are not aware of the extra burdens in this direction that are placed on the force and most of which extra duties are in excess of the regular police duties. There is no other department of the City Government from which so much is expected, and none for which generally so little is done; neither is there any department where the conduct of employees is so much scrutinized. Upon the slightest mistake made by one of them the whole police force is more or less subject to criticism. The public have no idea of the obstacles with which police officers have to contend; they have complaints in every shape arrayed against them.*[62]

THE CASE OF WILBUR E. PERRIGO

In May 1885, Officer Joseph A. LaRose sought out a man by the name of Wilbur E. Perrigo, alias Eugene York, a warrant having been issued for his arrest. While patrolling his beat, Officer LaRose spotted Perrigo sitting in a restaurant and approached the man. LaRose explained to Perrigo that there was a warrant for his arrest and moved to take the man into custody. As the officer had done countless times without incident, LaRose guided Perrigo by the shoulder and turned toward the courthouse. Without warning, Perrigo

struck at the officer with a knife, inflicting a five-inch gash in the area of LaRose's fifth rib, nearly killing him.[63] Perrigo fled but was later arrested by officers of the department. In the days following his capture, Perrigo escaped from the county jail by dislodging a few of the stones from the wall of his cell.

Several weeks later, Chief Barton received an interesting package at the jailhouse. The package had been addressed to "York." Inside, he found clothing that had been sent from Perrigo's mother in Chicago. Chief Barton alerted the authorities in Chicago, and by September, Perrigo had been recaptured.[64] While awaiting trial in 1886, under the supervision of Chief Barton, Perrigo plotted another escape, accompanied by another inmate. When the time came, the men sprung on Chief Barton, striking him repeatedly with a metal bar and a heavy mug.[65] Barton nearly died from the assault, and both men were eventually recaptured. Perrigo was sentenced to seven years at the state prison in Windsor, while the chief was left with a long recovery and physical disabilities that would plague him for the remainder of his life.

After serving his sentence, Perrigo returned to Burlington and once again found himself on the wrong side of the law. In August 1894, he stole money from a local restaurant and was tracked down by officers of the Burlington Police Department. When the officers approached him, Perrigo drew a pistol and fired several shots at Officer McElligott, who miraculously avoided serious injury.[66] After the shooting, the then chief of police, Jerome Dumas, went to Perrigo's house and wrestled the armed man into custody.[67] Perrigo was sentenced to a fifteen-year term in the state prison, where he died of cancer in 1902.[68] Wilbur Perrigo was one man, a criminal, who in two encounters nearly killed several police officers. His story highlights the unpredictable violence and dangers that have threatened officers of the department throughout its history.

In 1885, Elbridge S. Adsit was appointed chief of police to replace the wounded Chief Barton. Adsit was a Republican, which may have been the only criteria required of him to fill the vacancy, as he did not seem to have any prior law enforcement experience.[69] Despite his inexperience in the realm of law enforcement, Chief Adsit proved to be a strong administrator and maintained the department in good standing.

In 1887, William W. Henry was elected mayor of Burlington. Prior to becoming mayor, Henry had served as a constable in White Oak, El Dorado,

California, and as a colonel of the Tenth Vermont Infantry in 1864. He had fought at the First Battle of Bull Run, Cold Harbor and Cedar Creek and was awarded the Congressional Medal of Honor for his gallantry. Henry had also served as U.S. marshal for the district of Vermont for seven years.[70] As a new mayor looking for a chief of police, the hero of Cedar Creek would turn to a man with tested abilities. Joseph Barton was once again appointed chief of police. Still physically limited from being assaulted, Barton went to work addressing the deficiencies of the department. In addition to an expansion of the police patrol area, Barton advocated for a fully uniformed police department. Although Mayor Henry supported his efforts, the acquisition of police uniforms fell through when the board of aldermen failed to allocate the necessary funds. With the arrival of 1889 came unfortunate tidings; Chief Barton's health had worsened. Afflicted with breathing troubles as a result of his assault, Barton would not seek a new appointment. Instead, he took the advice of his physician and moved to Omaha, Nebraska, hoping that the climate would soothe his ailments.[71] Later in life, Barton would return to Burlington, where he died in 1892.

In his first address to the citizens of Burlington in 1889, Mayor William A. Crombie proclaimed that his focus, as it pertained to the police department, was to "select men who will be vigilant and faithful to their trusts."[72] His appointment of Jerome Dumas as chief of police was the embodiment of such sentiments. Dumas was a native Vermonter and a veteran sailor of Lake Champlain. From the age of fourteen, he worked aboard the steamships until he obtained the rank of chief mate. He first came to work for the department as an officer during the winter months and would return to his duties aboard the ships of Lake Champlain during the summer. It was in those winter months that Dumas would forge a reputation as one of New England's most vigilant lawmen.[73]

THE PICKPOCKET, A SERIAL KILLER AND THE MAD RIOT (1890-1899)

In 1890, the State of Vermont approved an act that provided a truant officer for the city. At a time when juvenile crime and delinquency needed to be addressed, the act granted the truant officer police powers in order to arrest any child during the portion of the year in which school was in session. Youths found in the streets, and not having lawful employment, would be brought to the superintendent's office, and their parents would be notified. If the child was habitually truant, the child's parents would be fined as much as twenty dollars. The truant officer was paid one dollar for each arrest of a truant child.[74]

In 1891, the citizens of Burlington elected the Honorable Judge Seneca Haselton to be their next mayor. During his political career, he would become known for a reorganization of city government, contributions to the school system and the acquisition of an electric railway system. Later in life, he would be appointed as the United States ambassador to Venezuela, and in 1902, he would be appointed to the Supreme Court.[75]

In 1892, Haselton commented that during the winter the city had given leeway when addressing the occurrence of "coasting," more modernly referred to as sledding, which was monitored under careful police supervision. Haselton was satisfied at the governance of the new sport, as there had been no reported accidents during that year.[76]

William J. Van Patten was elected to be Burlington's mayor in 1894 and was a powerhouse in both business and politics. He would implement several internal improvements such as the installation of the city's first permanent

roads and the planting of trees along its streets. But perhaps his most lasting contribution would come several years later. In 1902, he purchased a parcel of land, once owned by Ethan Allen, that included a two-hundred-foot cliff referred to as "Indian Rock."[77] It was on that overlook that Van Patten erected a stone tower as a memorial to Ethan Allen. The tower was built in the Norman style of architecture and stands above Indian Rock, which was used by Native Americans to keep watch over Lake Champlain.[78] The Ethan Allen Tower would later become a symbol for the police department, depicted on both the badge and police patch worn by Burlington police officers.

"MOLLY MATCHES"

In the summer of 1894, watches and wallets began disappearing from the coat pockets and purses of Burlingtonians at an alarming rate. Larcenies were common, but the frequency of the local reports made it clear that something unusual was at work. It was not until July 27 that the reason for these larcenies was discovered. On that day, Chief Dumas took a complaint from Mrs. Shepardson, who suspected a man of picking her pocket while she was boarding the train.[79] Dumas subsequently scoured the area and located a man in the area of the depot matching the suspect's description. The man identified himself as Dr. George Hickok, but Chief Dumas knew him by another name. Dr. George Hickok was, in fact, more infamously known as John Larney, alias Molly Matches, a notorious bank robber, bounty jumper and prison escapee.[80] He was also the most notorious pickpocket in American history. What Larney had not counted on was that Chief Dumas was a good friend of the famous New York City detective Thomas Byrnes, who had published a catalogue of famous American criminals in which Larney was featured as number eleven.[81]

Larney was from Cleveland, Ohio, and began his life of crime as a young boy. It was in his early criminal career that he earned the nickname "Molly Matches" when he pulled off the largest pickpocket heist in American history. It took place in New York during one of the city's larger celebrations. The streets were full of people whose pockets would soon be empty. In order to gain access to the crowd, Larney disguised himself as a match girl and proceeded to walk through the crowd, all too willing to offer gentlemen a match for their cigars. While lighting their cigars, he discreetly picked their

pockets. With a basket of matches in hand, Larney was rumored to have made $2,000 in the span of just a few hours.[82]

Later in life, Larney made a living as a bounty jumper, enlisting in military regiments nearly one hundred times in the states of Massachusetts, New York, Pennsylvania and Ohio. Larney would enlist, receive his pay and then desert to a neighboring state to repeat the crime.[83]

He was also a notorious bank robber, having robbed the Farmers and Mechanics Bank in Galesburg, Illinois, in 1882. In and out of reformatories and prisons, Larney spent most of his life in confinement. Most recently, Larney had escaped from a Massachusetts prison. In that case, during the first year of his sentence, Larney mysteriously lost his eyesight and was eventually given unsupervised use of the jail yard. His eyesight magically returned, and he escaped.[84]

Despite his criminal nature, Larney was not a violent man and found joy in fine clothes and good manners. He also viewed his career as a pickpocket as an artist views his paintings and considered himself a student of human behavior. He would watch people in a crowd and observe their movements and personal habits. He once told a reporter that he often targeted fat men because their nature was not normally one of nervousness, and they were not subject to fidget like thin people tended to do. Therefore, they were less likely to move suddenly or take notice of any pushing or jostling.[85]

In Burlington, with Larney's identity confirmed, Chief Dumas took him into custody and learned that Larney had recently deposited a large sum of money in the Burlington Savings Bank. It was suspected that Larney had been using the train depots between Troy, New York, and Burlington to practice his craft and make his living. At the time of his arrest, it was estimated that Larney had acquired nearly $500,000 over the course of his criminal career.[86]

IN 1895, THE LEGISLATURE passed an act that would drastically alter the practice of appointing police officers. Since the incorporation of the city, with each shift in the political landscape, the seated mayor would commence in appointing police officers from the ranks of his own political party. The legislative change attempted to balance the political influence over the police department by establishing a board of police examiners that would establish rules and regulations for officers and outline the needed qualifications for police appointments. Applicants deemed qualified would then go before the mayor for final approval. The law held that no more than two-thirds of the

applicants approved by the board could be from the same political party, provided there were enough approved applications to fill the positions.[87] Although the act was a step in the right direction, city politicians would continue to influence the ranks of the department for many years to come.

With new rules and regulations came a more professional approach to policing, and all hoped that just compensation would follow. On July 4, 1895, thirty years after the department was established, the department changed from a fee-based, per-diem system to a full-time, paid police department. Under this new system, officers would be guaranteed fifty dollars per month.[88]

Dr. Henry H. Holmes

In November 1894, a man by the name of Herman Mudgett, alias Dr. Henry H. Holmes, came to Burlington and rented the house at 26 North Winooski Avenue. The man was accompanied by two women, Mrs. Carrie Pietzel and "a blonde woman of striking appearance."[89] Shortly after Holmes arrived, Detective Frank P. Geyer of the Pinkerton Detective Agency came to Burlington and met with Chief Dumas. Geyer was looking for a man going by the name of Mudgett, and Dumas quickly recognized the man as being a newcomer to the city. Geyer was investigating an insurance fraud case in which Benjamin F. Pietzel had taken out a $10,000 insurance policy in the fall of 1894. Geyer believed that Mudgett, alias Dr. Holmes, had murdered Benjamin Pietzel and convinced Pietzel's wife that her husband was in hiding, waiting to collect the money on her behalf. Following the murder of Benjamin Pietzel, Dr. Holmes led Mrs. Pietzel to various cities, finally landing in Burlington, Vermont.[90]

The lawmen soon learned that Holmes had a letter at the post office and waited patiently for him to pick it up. When he arrived at the post office, Holmes stealthily slipped past Geyer but was relocated by Chief Dumas later that day at the opera house, in the company of his blond acquaintance. Dumas followed Holmes back to the house at 26 North Winooski Avenue, where Holmes evaded capture and promptly left for Boston. While in Boston, Holmes sent a letter to Mrs. Pietzel, who was still in Burlington, requesting that she look for a bottle of liquid that he had placed in the basement of 26 North Winooski Avenue. Mrs. Pietzel followed Holmes's instructions, found the bottle and ultimately hid it under a casement window.[91]

Not long afterward, Holmes and Mrs. Pietzel were both arrested. With his capture, Holmes admitted to the murder of Benjamin Pietzel and confessed to setting a trap in the North Winooski Avenue house in order to kill Mrs. Pietzel. It was learned that Holmes had hidden a bottle of highly explosive nitroglycerine in the basement and had rigged a trapdoor to fall on the bottle when anyone disturbed the objects surrounding it. To Holmes's disappointment, his trap failed, and Mrs. Pietzel luckily escaped with her life. Chief Dumas went to the house and recovered the bottle of nitroglycerine, carefully burying it in a place that was known only to him for safekeeping.[92] Chief Dumas also found chloroform, traces of lime and a few pieces of bone in the basement of the home, but physicians were unable to determine if the bones were human.[93]

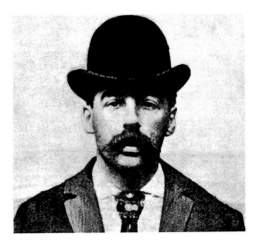

Dr. Henry Holmes, alias Herman Mudgett, America's first serial killer.

It was later discovered that Holmes had a much darker past than ever imagined. He had killed not only Benjamin Pietzel but also Pietzel's two children and buried their bodies in a home in Toronto. Postmortem examinations found that the children had been given chloroform injections.[94] Holmes was also traced back to a house in Chicago, where he lived in 1893. In Chicago during the World's Columbian Exhibition, nearly fifty fairgoers mysteriously went missing and were traced back to the home of Dr. Henry H. Holmes. When investigators searched the house, they discovered an "elaborate murder factory."[95] The house, which was personally designed by Holmes, was a three-story building consisting of ninety rooms. Inside the house, police found boxes of human bones and tanks of acid, which were used to dissolve his victim's bodies.[96] The castle was a maze of trapdoors and secret rooms, which contained gas pipes and alarms that would signal if his victims tried to escape.

In the end, Holmes confessed to murdering twenty-seven people, and it is believed that he may have killed as many as three hundred. Truman Mudgett, an alias he often used, attended the medical school at the University of Vermont from 1882 to 1883, but he never graduated.[97] Holmes later attended the University of Michigan, where he was expelled

for stealing corpses and experimenting on the bodies before filing false insurance claims.[98]

Herman Mudgett, alias Dr. Henry H. Holmes, was convicted of the murder of Benjamin Pietzel, and on May 7, 1896, he was sent to the gallows. It was said that prison officials mistakenly misjudged his weight, resulting in a botched hanging. When the hatch fell, Mudgett's neck failed to break, and he was left "jerking and writhing for 15 minutes" before strangling to death. Mudgett confessed to multiple murders, but he maintained that he was not at fault and that the devil made him commit the crimes.[99] Holmes is widely regarded as the first serial killer in the history of the United States.[100]

On February 4, 1898, the Burlington Police Department suffered a terrible loss in the sudden death of Chief Jerome Dumas. The vigilant chief died of Bright's disease, a condition that afflicts the kidneys. Although his health had recently taken a turn for the worse, Dumas had been haunted by tragedy for much of the previous year. In March 1897, his son, Joseph Dumas, who had been suffering from depression, walked into the secluded woods near the Burlington cotton mills and committed suicide.[101] Comforted by his family, Chief Dumas quietly mourned the death of his son while carrying out the duties of his office. Mayor Hamilton S. Peck expressed fine words of remembrance for the man who had devoted so many years to the preservation of order and prosperity.

> *It may fairly be said of him that he knew no fear. Neither threats of personal violence nor the loaded revolver in the hands of a vicious criminal, and pointed at a vital part of his body, deterred him. In a desperate cause, when nerve, good judgment and quick, decisive action were demanded, Chief Dumas showed himself at his best.*[102]

His fellow officers also commented on his character, recalling his "tireless energy and devotion to duty" as a "fearless guardian of peace, a terror to evil doers but a friend and protector of the weak."[103]

At the end of his last term, Mayor Peck appointed Loomis J. Smith to be Dumas's replacement. Chief Smith was an officer of the department and had served as a commissioned soldier in the First Regiment Infantry of the Vermont Militia and in the navy during the Civil War.[104] As the year unfurled, with the election of Mayor Elliot Sutton, it would become clear that Smith had unknowingly inherited an enemy in city hall.

The situation was a complicated one. When Smith was made chief of police, it was unclear if the appointment was for the remainder of Dumas' term or for an entirely new term. Both Mayor Peck and Chief Smith felt that the latter was the case, but the newly elected Mayor Sutton felt that the appointment was ill gotten and he should have the right to appoint the next chief of police.[105] Feeling as if his power had been usurped by his political rival, Mayor Sutton decided to take action.

On April 25, 1898, Mayor Sutton appointed Patrick J. Cosgrove to the office of chief of police, despite Chief Smith's existing appointment. In response, Chief Smith simply refused to give up the office and continued to carry out his duties. Frustrated by the prospect of a "double headed police department," Sutton ordered Chief Cosgrove to remove Smith's desk from the police office.[106] Chief Smith calmly watched as his desk was placed out on the sidewalk. Afterward, when it appeared as though it might rain, Chief Cosgrove quietly ordered that Smith's desk be placed in the Hook and Ladder room for shelter.

In what could only be a symbolic gesture, on July 4, 1898, Independence Day, Sheriff Thomas Reeves arrived at the police office and met with Chief Cosgrove. Reeves read to him an injunction signed by the Honorable Judge Rowell of the Supreme Court. The injunction restrained Cosgrove from performing the duties of the chief of police, and he was forced to surrender the keys of the police office to Chief Smith.[107]

Upon hearing of the injunction, Sutton rushed to the police office and ordered all the officers to put Chief Smith in jail if he attempted to act as chief of police. Despite the mayor's threats, Chief Smith continued to carry out the duties of the department. Frustrated by the actions of the court and the defiance of Chief Smith, Sutton declared himself acting chief of police.[108] Despite a request to expedite, the court would not rule on the issue until January 1899, after one of the most violent riots the city of Burlington had ever seen.

The Mad Riot of *1898*

In its early years, Vermont had been a leader in the abolitionist movement, but the plague of racial prejudice was still readily apparent in the fall of 1898. It was on September 8, 1898, aboard the *Reindeer*, a well-known steamship in the Champlain Valley, that an incident occurred that would ignite a riot, pitting Vermont soldiers against the officers of the Burlington Police Department. The

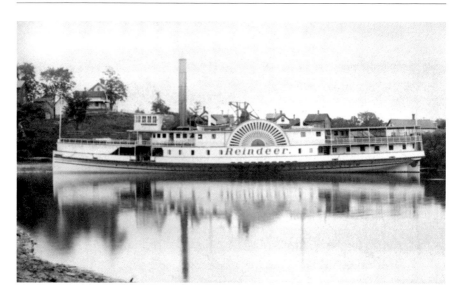

The *Reindeer. The Bixby Memorial Library, Vergennes, Vermont.*

following headline was printed in the *Burlington Free Press*: "Two Soldiers struck down by the Darkies who used billies—Soldiers seek revenge and threaten to burn the boat—Pelted the Negroes with Bottles—Officers hurt."[109]

"Burn the boat!" cried the infuriated soldiers of the First Vermont Regiment as the *Reindeer* docked at the Burlington waterfront.[110] Since the ship had departed Plattsburgh, members of the First Vermont Regiment had been engaged in a brawl with two members of the crew, John and Charles Wallace. It was reported that had it not been for the actions of four Burlington police officers, the fight would have ended in a lynching or burning.[111]

As the ship was leaving Plattsburgh, a group of soldiers had gathered around a boy who was dancing on the rear deck of the ship. The soldiers claimed that the Wallace brothers, described as two Negroes who were employed with quelling disturbances on the ship, unjustly took the boy below deck, spoiling their entertainment. The Wallace brothers claimed that the soldiers had been fighting and they removed the boy for his own safety. Regardless of the circumstances, the soldiers demanded that the boy be freed, and a fight broke out. John Wallace struck two soldiers with a billy club, while his brother, Charles, was unmercifully beaten by the soldiers. Lieutenant Fuller pushed through the crowd and temporarily protected the Wallace brothers from the angry soldiers. As the ship slowly lurched eastward, the mob of soldiers proceeded to drink heavily, having found a large quantity of liquor stored on the ship for excursionists. As the steamer

settled into the Burlington docks, the soldiers gathered and used every conceivable object to throw at the Wallace brothers as they attempted to leave the ship. Lieutenant Landon was the first ashore and telephoned the police station requesting "the whole force" to come to his aid.[112] Officer Coffey was on the scene when the ship reached the dock and took charge of Charles Wallace. Officers Graton, Kelley and McElligott arrived in time to see the second wave of the riot break out. It was said that "bottles shot through the air like meteors and one of them struck Officer Graton over the left ear, inflicting an ugly gash."[113] It was reported that "blood trickled down his neck and dyed his shirt collar a deep red."[114] Despite the injury to his head, Officer Graton continued to fight off the mob.

As the boat was being tied down, John Wallace escaped into the dining room of the ship, where he pulled up some of the floorboards and dropped into the hull of the ship. From there, he climbed up onto the paddle wheel, where he was later found by a police officer. After a guarantee of protection, Wallace was smuggled off the ship past the angry mob. Once ashore, the Wallace brothers were placed in a cart and transported to the court under a barrage of glass bottles.[115] The wounded soldiers, both of whom had remained unconscious throughout the voyage, were taken to a hospital, where it was determined that their injuries were not fatal.

Seeing that the Wallace brothers had escaped, the crowd of drunken soldiers marched to Church Street to wait for their release from court. To complicate matters, Judge Russell and other officials debated whether the City of Burlington had jurisdiction over the case. Being on Lake Champlain, it was unclear whether the fight had occurred on the New York side of the lake. The captain and the pilot of the ship were called on to give testimony, but no definitive claim could be made. By the afternoon, it had been decided that the case would be heard in city court, and it was said to attract one of the largest crowds ever in the building.

After a half-hour session, the court adjourned for the day. The Wallace brothers were ordered back to the jail, while the soldiers waited outside to abduct them. The crowd became so unruly that Mayor Sutton sent for Colonel Clark and a detachment of soldiers from Camp Olympia to help maintain order. The incident also shed light on the strained relationship between Mayor Sutton and Chief Smith, who waited quietly in his office while Mayor Sutton nervously tried to quiet the ringleaders of the mob. To display his leadership, Mayor Sutton ordered Officers Cosgrove and Coon to keep the mob away from the doors of city hall. Aware that such a task was not as simple as the mayor suspected, Coon began ordering the crowd

to back up, but it refused. Officer Coon began shoving those who disobeyed his orders, and in response, several people rushed at him. He was saved from serious injury by the swift intervention of his fellow police officers.[116]

As evening fell, a squadron of fifteen soldiers arrived to assist the outnumbered police officers. Thinking that the soldiers had come to support their violent intentions, the mob rejoiced. The *Free Press* reported that "cheer after cheer went up as they alighted from the electric car. Cries of 'Shoot the niggers. Take care of your own soldiers. Mob them. Remember the *Reindeer*!'"[117]

Lieutenant Putnam stationed his soldiers on both sides of Church Street and gave orders to his men to not make any trouble. At that time, Private Stevenson, one of the soldiers who had been injured, climbed a telegraph pole and, with a white bandage on his head, stoked the mob's anger. While the crowd was expecting the Wallace brothers to be brought through the main entrance, Sheriff Reeves arranged for a cart to arrive near city hall with the instructions to drive as fast as possible as soon as the Wallace brothers were onboard. Word was sent to the crowd that the Wallace brothers were coming out, while officers quietly smuggled them out the rear of the building. Several onlookers saw the men leaving and alerted the mob. The crowd proceeded to chase the cart as it raced toward the jail. As the Wallace brothers climbed the jailhouse steps, the mob hurled stones at them and the police officers who were escorting them.[118]

The Wallace brothers remained in the jailhouse, charged with the assault of the two soldiers, until September 12, when Judge Russell ruled that the court had no right to prosecute the two men. Judge Russell ruled that the incident had occurred outside the jurisdiction of Chittenden County and the State of Vermont. With the support of prosecutors, the Wallace brothers were set free.[119]

The *Free Press* reported, "All in all it was the worst exhibition of mob violence that has taken place in Burlington within the memory of any citizen."[120] The riot showed that Burlington was not free from the ugliness of racism, and the handling of the riotous crowd signaled a clear lack of leadership in city hall and drew greater attention to the rift between Mayor Sutton and Chief Loomis J. Smith. Mayor Sutton would not be reelected. What must be remembered is that on that horrible day, when all others were swept up in the tide anger and hatred, the officers of the Burlington Police Department, despite their personal beliefs, fulfilled their duty and risked their lives to save two men from certain death.

THE RIOT OF 1898 resulted in a loss of support for Mayor Sutton, and his future as a politician was bleak. Adding insult to injury, on January 26, 1899, the Supreme Court ruled in favor of Chief Smith, supporting his appointment as chief of police until March 16, 1901. The court also ordered that Mayor Sutton pay for the cost of the court proceedings. Like so many unlearned lessons of history, this would not be the last feud between a mayor of the city and a chief of police.[121]

In 1899, as anticipated, Robert Roberts was elected to serve as mayor. Under Mayor Roberts, Chief Smith pushed for additional police appointments so that the department could more adequately patrol the outer limits of the city. His request would go unfulfilled, and he would be forced to wrestle with a plague of intoxication arrests and a rash of pickpocket offenses that swelled during the summer months. At the end of a seemingly mild year, the department would investigate the grisly murder of Agnes Willis.

THE MURDER OF AGNES WILLIS

On December 14, 1899, Agnes Willis, "a well known colored woman," was found murdered, with her throat cut.[122] Willis's body was discovered by her sister in the bedroom of her house on Cherry Court, and suspicion quickly fell on Gilbert Farmer, a man with a bad criminal record. Farmer had committed several burglaries and robberies throughout the city, and his picture was on display in the Rogue's Gallery at the police office. Farmer had been seen entering the house with Willis in the hours before the murder took place.

When the police were notified, an officer was sent to inform Mr. Willis of his wife's murder, while Chief Smith conducted an examination of the body. The wound that had caused her death extended from below her left ear and stopped just beyond the trachea.

In the hours following the murder, Chief Smith went to Lafountain Street, where he conducted a search of the residence belonging to Farmer's mother. He also conducted a search on Oak Street, at the home of Farmer's brother. In an interview with Chief Smith, Farmer had indicated that his knife was at his mother's house in a drawer, but during the search, Chief Smith found only a dull pocketknife.[123]

While Farmer sat in jail charged with murder, the unexpected happened. In the early hours of an otherwise unremarkable morning, Gilbert Farmer

confessed. It was breakfast time at the house of corrections, and after a brief conversation with Sheriff Reeves, Farmer admitted to killing Agnes Willis. Farmer told of how he and Willis were in the bedroom when he began fooling around with his knife. Farmer stated that he suddenly grabbed Willis by the neck and cut her throat. He claimed he was standing in front of Willis when it happened and that his hands were covered in blood. Farmer also told Reeves how he put the knife in his pocket when he jumped from the stairs and fled down Battery Street. Farmer then went to his mother's house and gave her the bloody knife.[124]

At the end of the conversation, Farmer began to retract his statement, saying that Willis had cut her own throat and that he did not kill her. Sheriff Reeves examined the clothing that Farmer was wearing and turned the pockets of Farmer's pants inside out. The pockets had dried blood on them from when Farmer had placed his bloody hands and knife in them. Sheriff Reeves then cut the pockets off of Farmer's pants and submitted them as evidence to the court. Farmer was later convicted of the murder of Agnes Willis and sentenced to life in prison.[125]

On December 15, 1899, the day after the gruesome murder of Agnes Willis, Chief Smith resigned from office. The reason is not known, but one can imagine that the gruesome homicide and Smith's time under Mayor Sutton surely had taken a toll on him. Mayor Roberts chose Edward F. Brownell to finish out Smith's term as chief of police.

THE DEATH OF A POLICEMAN
(1900-1909)

In 1900, the department had eleven paid regular officers, but with additional patrols added to the train depot and steamboat landing, Chief Brownell's resources were stretched thin. To complicate matters, the city's insurance companies demanded more patrols at the lumberyards and adjacent streets under the threat of increasing insurance rates. In addition to staffing issues, the department was suffering from low morale. Low pay, internal conflict and the daunting nature of the work all combined to place the department in a precarious position.

In 1901, Chief Brownell added a patrol to Bank Street and designated the department's first animal control officer, John H. Ryan. Despairingly reflective of the times, his official title was "dog killer."[126]

On December 11, 1902, the Vermont legislature passed an act regulating the trafficking of intoxicating liquors. The law was a political compromise between the temperance movement and the blatant smuggling and use of alcohol in the state. The law called for a referendum vote and would allow the citizens to decide for themselves if liquor should be legal. In 1903, the vote was cast, and the local option passed by a 1 percent margin. Prohibition had come to an end.[127]

At a time when liquor was sure to increase their workload, Brownell recognized that his officers were being paid far less than officers in Montpelier, Barre and Rutland. In recognition of the chief's concerns, the city increased officers' pay to fifty dollars per month for those serving one year, fifty-five dollars per month for those serving three years and sixty dollars per month for officers in their fifth year.[128]

MAYOR JAMES E. BURKE

Throughout the late 1800s, city politicians in America had become well practiced in the art of corruption to varying degrees. In major cities like Boston and New York, police officers were often used as political operatives during local elections.[129] As a result, many politicians, while in power, attempted to appoint police officers from their own political party in order to secure reelection. Although there is no definitive evidence confirming that such tactics were used in Burlington, with the election of 1903 it became clear that political shenanigans were present. At the end of May 1903, James E. Burke was elected mayor of the city of Burlington over the incumbent, Mayor D.C. Hawley.

The election was a close contest, and it was initially determined that Hawley had won by a vote of 1,565 to 1,562. However, it was later learned that the voting box for Ward 2 had been tampered with. To complicate the matter, several ballots that had been cast for Mayor Burke were not counted because they appeared improperly marked.[130] In this nest of political trickery, it was hard to see which side was more culpable. With these exceptional circumstances, the matter was brought before the Supreme Court, which declared James E. Burke the winner.

Burke was the son of Irish immigrants and settled in 1873 in Burlington, where he established a small blacksmith's shop at 137 South Winooski Avenue. Burke's neighborhood, Ward 3, was an ethnic boiling pot of Irish, French Canadian, Jewish and Italian immigrants who lacked representation in city government. As an Irish Catholic, Burke entered city politics and fought hard as a representative of the poor and working class.[131] However, Burke also became known for his fiery temper and an ongoing rivalry with Hamilton S. Peck, a Republican and former mayor of Burlington. Repeatedly ousted and reelected over the course of several decades, Burke would be credited with establishing a water filtration plant, a municipally owned electrical plant and a public dock; the construction of Union Station; and the creation of a municipal employees' retirement fund.[132]

In his first year, Burke went to work declaring a political war on the Burlington Police Department. It is unclear whether he sought to purge the city of the corruption that nearly cost him the election or whether he was attempting to supplant officers to ensure his reelection. Whatever his aim, he pursued it with fierce intention. In the following year, under the guise of reform, Burke personally orchestrated complaints of misconduct and leveled allegations against officers, most of which proved to be unfounded. Frustrated in his efforts, Burke altered his approach. If he could not control the arms of the department, he

would aim for its head. He then turned his attention toward Chief Brownell, a known Republican. In June 1903, Burke suspended Chief Brownell and declared himself the department's chief of police.[133]

At a hearing of the board of police examiners, Burke filed charges against Chief Brownell, and the board responded with two reports—a majority report and a minority report. The majority report held that the charges were unfounded, while the minority report indicated that the charges were sustained.[134]

Burke charged Chief Brownell with having acted as a chairman of a political caucus and attending a political meeting, which was against the rules of conduct for an officer. Both reports found that Brownell did attend the caucus, but there was no evidence to support the claim that he had made a political speech at the event. The matter hinged on interpretation and would have to be settled by the court. In the meantime, Mayor Burke appointed Officer Russell to be chief of police and ordered all policemen to ignore the orders of Chief Brownell.

Mayor James E. Burke, 1913. *The Burlington Police Department.*

After many delays, on August 14, 1903, the board of aldermen heard testimony regarding the charges against Chief Brownell. In addition to the political allegations, one witness testified to a more explicit charge against Chief Brownell. Miss Rose Miller testified that while she was meeting with Chief Brownell in the police office around the time of the political event, Brownell had locked the door and indecently placed his hands on her waist.[135] Several more witnesses suspiciously came forward, bringing charges of political violations and accusations of debauchery against Chief Brownell.

On August 20, 1903, the police examiners ruled that although Brownell was present at the political event, he did not partake in conduct that violated rule

Chief Patrick J. Russell, 1913. *The Burlington Police Department.*

number thirteen of the police rules of conduct. The panel found Brownell not guilty on all charges relating to the political caucus. A charge against Chief Brownell accusing him of drinking heavily and engaging in debauchery with women of ill repute was also found to be unsubstantiated. Rose Miller's complaint was also addressed, and the investigation found that Miller was, in fact, a prostitute and that her complaint had been made in response to Chief Brownell attempting to correct her behavior. The examiners found that Brownell did not make any inappropriate proposals or suggestions and was not guilty of conduct unbecoming of an officer.[136] Against the weight of an angry mayor and eleven charges of misconduct, Chief Brownell emerged victorious and was acquitted.

In the end, Mayor Burke refused to lift Brownell's suspension and appointed Patrick J. Russell as chief of police. To deliver a more firm punishment, Mayor Burke refused to authorize Brownell's salary for the time he had served. Although Brownell proceeded to challenge Mayor Burke's actions in February 1904, the Supreme Court upheld Burke's decision based on evidence that Chief Brownell acted as a chairman in a political caucus.[137]

IN 1904, CHIEF RUSSELL recommended that the city install a Gamewell System, a recent invention that was being used in every major city in America. The Gamewell was the earliest innovation in police communications, combining both telephone and telegraph technology. Through a series of light poles installed throughout the city, a signal could be sent from the police office to the patrol beats of the city. When

a light pole was illuminated, the patrolman would go to the call box and speak directly with the police office to see where he was needed. Chief Russell believed the Gamewell System could greatly increase the efficiency of the department, but like most innovations, the cost would be carefully weighed by the city.

The Death of Officer James P. McGrath

On May 19, 1904, Officer James P. McGrath was finishing up his evening patrol of the lumberyards when he came upon a stranger. Without warning, the man shot McGrath and fled from the scene. Police officers rushed to the area and quickly carried McGrath to his residence at 187 North Champlain Street. He died before reaching his home. McGrath's body was examined by Dr. Clark and P.E. McSweeney, who found three bullets in his chest. The bullets were extracted and found to be of .38 caliber, a type often used by military officers.[138]

A witness, Joachim Labarge, described the stranger as wearing a soft hat and having black hair and a black moustache. He also saw a metal object on the murderer's vest, suggesting that he might have been a deserter from Fort Ethan Allen. Labarge, who lived at 20 Main Street, stated that he first saw the two men walking up Main Street away from the lumberyards. When they neared his house, the stranger turned and shot McGrath in the chest at close range. McGrath did not fall after the first shot, and the man quickly fired a second time before retreating. McGrath tried to pursue the stranger, but the man turned and fired a third time. From there, the man ran toward the lumberyards before firing a fourth time at the already wounded officer. McGrath pursued the man as far as Joseph Richard's boat shop before he collapsed. The sound of the shots prompted telephone calls to Dr. McSweeney and police headquarters. Awaiting the arrival of the police, citizens gathered, and a woman knelt beside McGrath, praying the rosary. As McGrath lay in the middle of Main Street, Father Gillis administered the last rites.[139] Chief Russell responded with a large group of officers and conducted a full search of the lumberyards, but the suspect was gone.

A second witness, Francis Lavalee, a watchman at the Shepard & Morse lumberyard, reported that he had seen McGrath walking with a man just before the shooting. McGrath had his hand on the man's shoulder, and the

Officer James P. McGrath, the first Burlington police officer killed in the line of duty. *The Burlington Police Department.*

stranger was overheard saying, "If I go back, they will put me in the guard house."[140] After the shots rang out, Lavalee saw the man running through the lumberyards toward the waterfront. He then saw a man in a boat pull away from the shore and disappear beyond the breakwater. Lavalee stated that the man wore a soft hat.

Later that night, Chief Russell received word from Vergennes that a man matching the suspect's description had arrived in town on the train from Burlington. A constable was sent to find the man, while Chief Russell called for additional resources. A bloodhound was brought to the scene and quickly picked up the trail of the murderer. The track proceeded through the lumberyards toward the docks. Once the dog reached the water, he lost the scent.[141]

On the following morning, Constable Myatt arrived at the train station in Vergennes and was informed by the conductor that a man matching the description of the murderer had climbed aboard the train while it was stopped for repairs. Myatt was warned that the man was unsavory looking and was urged not to attempt the arrest alone. Despite the warning, Myatt entered the train car and arrested the man, who was huddled in the corner. He was found with a .38-caliber revolver.[142]

While the suspect was held in jail at Vergennes, a reporter interviewed him; he claimed to be John Thompson, a twenty-two-year-old born in London, England. The man was transported back to Burlington and arrived amidst a crowd of people hoping to see the man suspected of killing Officer McGrath. Several officers were dispatched to the train depot to maintain order and prevent any actions of the crowd. When the train arrived, the man was escorted in a horse-drawn cart up Main Street, passing by the very place where the murder had occurred. As the

cart passed by the place where McGrath died, the driver noticed that the man was glancing uneasily at the ground. The cart driver said, "Take a good look for it is the last you will get."[143]

Upon arrival at the police office, the stranger was interviewed by Chief Russell. The man had hardly taken a seat before he told Chief Russell his real name and rank in the military. His name was Benjamin Williams. Williams told Russell that he left his post several days ago and took a train to Montreal. After a brief stay, he returned to Burlington on the night of the incident and fell asleep in the lumberyards. He claimed that the next morning, he climbed aboard the freight train on which he was arrested. During the interview, Chief Russell noticed that both of Williams's shoes appeared to have shrunk from exposure to water, and his trouser legs were muddy and wet. Joachim Labarge was called to the police office but was unable to confidently identify Williams as the murderer. Afterward, Williams was put through a well-known interrogation technique of the day: the third degree. Throughout his interrogation, Williams remained adamant that he was not guilty. Williams was searched at the jail, and Sheriff Horton found three .38-caliber cartridges in his pockets, one of which was grooved with a knife. Francis Lavalee, the other witness, was also brought to the jail and identified Williams as the man he had seen walking with Officer McGrath just before the shooting. Lieutenant Ely of Fort Ethan Allen also assisted in the investigation and identified the revolver, bearing the serial number #152079, as the gun that was issued to Williams. The revolver was a standard Colt army revolver and was found to have been fired recently.[144]

Officer McGrath's funeral was held at St. Mary's Cathedral and was the most widely attended funeral in Burlington history. Chief Russell and the entire police force were in attendance, along with McGrath's widow and two children. Officers Cosgrove, Garrow, Marengo, Ryan, Brothers and Delaney served as pallbearers and lowered McGrath into his final resting place in St. Joseph's cemetery.[145]

When the date of Williams's trial was set, his attorneys submitted a request to transfer him to the state hospital in Waterbury for evaluation. Of the four physicians who met with Williams, three found that he was sane, and the fourth was uncertain if Williams was insane or merely acting disturbed. Given their testimony, Judge Haselton ruled that Williams was fit to stand trial.[146]

The prosecutor opened his arguments by calling Dr. Clark to the witness stand. Dr. Clark had been called to the jail to examine Williams, who claimed to have contracted malaria while in the Philippines. While being treated, Williams confessed to Dr. Clark that he had shot McGrath.

Williams stated that he warned McGrath repeatedly to let him go and asked McGrath to throw up his hands or he would shoot. When McGrath refused, Williams shot him in the chest. Dr. Clark then asked Williams about the creased bullet that was found in his possession. Williams explained that the creased bullets were used in the Philippines and inflicted larger wounds than uncreased bullets.[147]

Perhaps the most moving testimony came from Mrs. McGrath, the widow of the murdered policeman. She testified that her husband had been in good health when he left home that night and that she did not see him again until he was brought home dead. With the evidence firmly presented, the state rested its case against Williams.[148]

On October 11, 1905, the jury convicted Benjamin Williams of the killing of Officer McGrath. Judge Haselton sentenced Williams to life in prison with hard labor at the state prison in Windsor. Throughout his sentencing, Williams remained silent and appeared emotionless. It was said that during his first year of imprisonment, Williams did not utter a single word and communicated only through motions of his head and body.[149]

IN MARCH 1907, Mayor James E. Burke failed to win reelection. But before his departure, Burke strongly urged the board of aldermen to purchase a Gamewell System for the city. Burke referenced the recent damage and loss caused at the Burlington Light & Power Company due to a gas leak and subsequent fire. He argued that the damage could have been minimized if a system like the Gamewell had been in place. On April 24, 1907, the city purchased and installed the Gamewell System, consisting of twenty-two call boxes and one main cabinet, at a total cost of $4,800.[150]

On April 25, 1907, under Mayor Bigelow, the city took steps to insulate the police department from political influence. An amendment to the city charter was enacted that dissolved the board of police examiners and replaced it with a board of police commissioners. The change was accompanied by a policy that required police applicants to live in the city for one year and be legal voters in order to be eligible for a police appointment. The ability to read and write the English language was an added requirement, while anyone who was convicted of a felony or other serious misdemeanor crime was ineligible. Men with a minimum age of twenty-five years but no older than forty were accepted, and there was a height and weight requirement eliminating any applicant shorter than five feet, eight inches tall or lighter than 150 pounds.[151]

In March 1909, James E. Burke returned to city hall by a margin of eighteen votes.¹⁵² Under Mayor Bigelow, the police department had been subjected to public criticism and administrative opposition, but such hardships were tolerable when faced with the alternative. With his return, Burke resumed his fight against the department, and by the end of year, the board of police commissioners had investigated six police officers on a variety of charges, many of which were ruled unjust by the city and the court.

The Shooting of Officer John H. Ryan

On the morning of November 8, 1909, in the area of South Winooski Avenue, Officer John H. Ryan observed a suspicious male. The man, later identified as John A. Thomas, initially refused to identify himself, so in an effort to detain him, Officer Ryan grabbed the stranger by the collar. Thomas resisted and suspiciously reached into his coat pocket. At that same moment, Officer Collins arrived and grabbed Thomas from behind. During the struggle, Thomas fired a shot from inside his overcoat, striking Officer Ryan in the left thigh. Thomas was wrestled to the ground, and the revolver was knocked out of his hand. Thomas continued to fight the officers, and it was reported that Officer Collins twisted the shackles so tightly on Thomas's wrist that they broke and a second pair was needed to bind the man.¹⁵³ With Thomas in custody, Officer Ryan was rushed to the Mary Fletcher Hospital for treatment. It was determined that if not for actions of Officer Collins, the bullet would have entered Officer Ryan's abdomen or chest and could very well have been fatal.¹⁵⁴

Sergeant John H. Ryan, 1913. Ryan would go on to become the department's first deputy chief. *The Burlington Police Department.*

Further investigation found that Thomas had recently been released from an insane asylum in Newberry, Michigan.[155] At trial, it was determined that Thomas was mentally ill, and he was committed to the state hospital for observation and treatment.[156] Officer Ryan would eventually recover from his injury and go on to serve as an officer of the department for thirty years.

A WOMAN IN THE RANKS (1910-1919)

In 1910, under the continued command of Chief Patrick J. Russell, the department made 629 arrests, 384 of which were for intoxication. Other offenses included prostitution, adultery, arson and larceny. Astonishingly, the department returned thirty-one lost children to their parents in that year.[157] However, motor vehicle traffic in the city was of paramount concern, as was the reckless operation of automobiles, which contributed to increased occurrences of motor vehicle–related injuries and deaths.

THE UNIVERSITY OF VERMONT RIOT

On May 20, 1911, chaos visited the Queen City, and it was found to be a fan of the nation's greatest pastime. It was on that day that the University of Vermont baseball team won a victory over Dartmouth by a score of 10–0. The cheerful celebration that followed poured into the streets of Burlington and spiraled into a violent riot. It all began when students marched downtown in a nightshirt parade, led by a marching band. A bonfire was started at the city market grounds, and students began using any detachable property to fuel the fire. Stepladders and lumber were taken from the business of O.R. Stone, along with other items snatched from under Mayor Burke's blacksmith shop. The students burned several signs, and two wagons from the National Biscuit Company were nearly dragged into the blaze. Due to

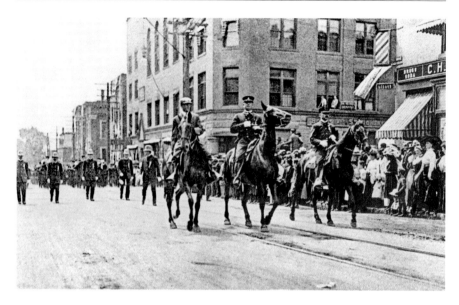

A police parade, circa 1910. *The Burlington Police Department.*

the southwesterly wind, the fire was fanned toward the livery stable and the garage of the Vermont Motor Company. To make matters worse, the fire was dangerously close to the C.P. Smith Feed Company, which was filled with a large quantity of hay. A spark from the bonfire eventually landed in the Vermont Motor Company's garage, and a small fire ignited. Luckily, the fire was extinguished, but the fire department was called on to address the issue of the bonfire.[158]

Chief Niles and his men arrived with a hose wagon and laid a line from the hydrant at the corner of South Winooski Avenue and College Street. As soon as the hose was in place, the mob of students pulled the firehose away from the firemen. Niles tried to reason with the drunken students and warned them of the danger that was present. Some dispersed, but the majority continued on their path of destruction. Another attempt was made to disrupt the firemen, and this time Chief Niles fought back. Despite his efforts, the mob of students quickly overpowered the fire chief and threw him to the ground. Captain Carty and several other firemen came to his aid, but they were also thrown to the ground. A block away, students attempted to tear up the fence in front of the jail, but Sheriff Todd was able to interrupt them before being swarmed and assaulted. Officers Lynch and Vincent were the only members of the police force at the scene, and they were able to fight off the mob long enough for the bonfire to be extinguished. Eventually, even they were overpowered.[159]

The crowd then forced its way into the Strong Theatre, where the Gladys Klark Company was presenting a showing of *My Dixie Girl*. The mob overpowered three police officers at the door and interrupted the entire production. The students then marched up Church Street and piled onto an electric trolley car, where they attempted to pull the conductor, Edward McGettrick, from his seat. McGettrick defended himself with an iron rod, which angered his intoxicated assailants. In retaliation, students began cutting the bell ropes on the trolley as it pulled away heading northbound. Loaded with passengers, the trolley slowly made its way to Winooski, where a group of students had gathered to seek revenge on the conductor. They were armed with sticks and revolvers. Luckily, the acting president of the university, Elias Lyman, learned of the trap and, with the help of the police, intercepted the trolley before it arrived. Lyman then addressed what was left of the mob, and under the threat of serious administrative punishment, the crowd of students dispersed.[160]

The Shooting of Officer Christopher Miles

On June 16, 1911, Officer Miles made his way to 48 Ward Street with an arrest warrant in his hand in search of Joseph Ploof. The police had been looking for Ploof, who in the days prior had threatened his wife with a gun. When Officer Miles arrived at the residence, it appeared that no one was home, but Officer Miles soon heard heavy footsteps in the upstairs of the house. Minutes later, the Ploof family returned home, and Miles stated that he believed their son was hiding inside.

With their consent, Miles entered the house and walked slowly upstairs toward Ploof's bedroom. At the top of the stairs, he came face to face with the man he had been looking for. Miles explained to Ploof that he had a warrant for his arrest, and after a brief conversation Ploof agreed to go with him. Assured of Ploof's compliance, Officer Miles walked downstairs while Ploof tended to his belongings. Without warning, Ploof emerged from the bedroom with a revolver and shot Officer Miles in the back. Miles staggered down the stairs and turned just in time to see Ploof turn the gun on himself and fire two shots into his own chest. Bleeding badly, Officer Miles stumbled to the patrol wagon and was rushed to his home. A doctor was summoned, and although his wound was believed to be fatal, Miles refused to allow himself to be undressed or medically treated until he was administered the

last rites by a priest. Father Gillis arrived shortly after and administered the last rites while doctors accompanied Miles to the hospital.[161]

After the shooting, Officer John H. Ryan, Officer James W. Gorman and Sheriff Allen were sent to the scene. They found Ploof lying on the couch in his father's room, where he denied shooting Officer Miles. The officers recovered the .32-caliber Hopkins and Allen revolver that had been used to shoot Miles and transported Ploof to the hospital.

Five days after the shooting, on June 21, Officer Miles was suffering greatly due to the bullet that was lodged in his lung, and doctors feared that pneumonia might set in. Joseph Ploof, however, was resting comfortably. Both of his self-inflicted bullets were treated without serious complications. The first bullet had entered the chest and traveled out toward his armpit, while the second bullet had lodged just below his heart.[162]

Doctors painted a dreary picture of Miles's chances of survival, and many thought the patrolman would die, but Officer Miles was no ordinary man. In fact, he was exceptional. Miles was not only one of the most popular men among the ranks of the department, but he was also known for his physical strength and courage. In the weeks before the shooting, residents of the Old North End had petitioned to keep Miles from being transferred to another area of the city, as he was known to be an efficient and faithful officer.[163] It was also well known that just three months earlier, Miles had rescued a young girl from inside a burning building on Murray Street. In that incident, Miles rushed into the blaze and carried out the girl, who was still engulfed in flames. Unfortunately, the girl died from her injuries, and Miles received debilitating burns to his hand. He would never fully recover because some of the tendons in his hand were completely burned through.[164] Miles was unable to work for several weeks but later returned to duty. Despite the seriousness of his current condition, he would eventually heal and return to his duties as a patrolman. Throughout the remainder of his career, he carried with him the .32-caliber round that remained embedded in his lung.

At arraignment, Ploof was charged with the shooting of Officer Miles before being sent to the hospital in Waterbury for evaluation. At trial, Officer Miles testified that a bullet in one's back feels somewhat like the sudden blow from an axe. While testifying, he wore the same coat that he had worn on the day of the shooting and showed the jury the bullet hole in the back of the coat and the bloodstain that surrounded it.[165] The defense argued that Ploof was insane, and one witness who observed Ploof in the hospital stated that Ploof was seen jumping off his bed in an attempt to climb the walls of the room. Ploof also complained of seeing devils and

snakes jumping from around the porch railings of the hospital. In addition, he was observed motioning as if he were fishing off the hospital veranda. However, other counter-witnesses from the hospital believed that Ploof was faking this delusional behavior.[166] At the end of the trial, Joseph Ploof was convicted and sentenced to serve seven years in the state prison in Windsor. It would prove to be a life sentence. Ploof died in the state prison in October 1913.[167] Officer Miles continued to work as a police officer until 1924, when he died of pneumonia. His death certificate lists his old bullet wound as a contributing factor to his death.

By 1912, the awe and curiosity that had originally greeted the automobile in the Queen City were beginning to fade. More and more automobiles had taken to Vermont roadways, and the city worked tirelessly to keep the streets in fair condition for residents and touring visitors. However, no amount of roadwork could reduce the shocking number of accidents and injuries that were occurring on a weekly basis. Dating back to 1898, the state had prepared legislation in anticipation of the arrival of the automobile, but the scope of problems caused by reckless driving was much larger than expected. Part of the problem was that automobiles shared the roadways with horse-drawn carts and carriages, as well as the electric trolley cars that traveled throughout the city. Without the necessary tools for enforcement, unskilled automobile operators continued to terrorize the streets of Burlington.

In 1913, the city approved the purchase of several automobiles for various departments within the city. Initially, a single police automobile was purchased for the police department,[168] and in 1914, the city added a combination patrol-ambulance.[169] With the arrival of the two automobiles, the police department entered the automotive age.

In the spring of 1913, Mayor Burke was reelected by the citizens of Burlington. Unlike his previous terms in office, and as a much older man, Burke would not wage another war on the police department. With the exception of his veto of a proposal that would issue police officers winter frocks in 1914, Mayor Burke did not engage in further action against the ranks of the department.[170] Although he seemed content with the police department, Burke's political fight was not over. The fiery blacksmith turned his focus on direct political action and carried out an offensive against the city's water commissioners, leveling charges of misconduct, negligence and incapacity against them.[171] In July, Burke also criticized the management of the Street Department in a similar fashion, which resulted in a series of

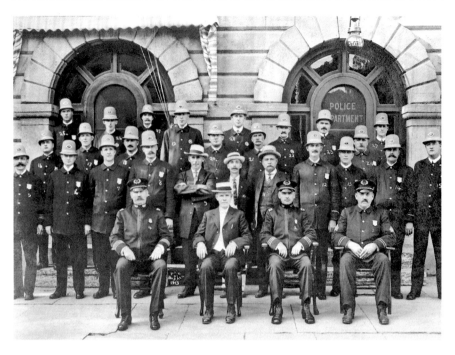

The Burlington Police Department in 1913. *The Burlington Police Department.*

contentious meetings between Mayor Burke and members of the board of aldermen. At one such meeting, the debate became so contentious that the police were called to maintain order.[172] Burke's actions continued throughout the following year, but in the end, after he hurled an array of allegations at his political opposition, the Supreme Court ruled that Mayor Burke's actions were unwarranted. As a result, on March 4, 1915, Mayor Burke submitted his resignation.[173]

In 1917, J. Holmes Jackson was elected mayor, but he came into office at a difficult time. On April 6, 1917, the United States declared war on Germany and joined the Allied Forces of World War I. In May, a patriotic parade was held, and nearly four thousand people marched through the streets of Burlington, but their cheers would depart with the soldiers and become lost in the news of endless casualties and deaths.[174] As the war in Europe raged on, the officers of the department continued to protect and serve the city through a time of economic hardship and social change.

Also in 1917, the Vermont legislature enacted a law allowing women to vote at city meetings. Supportive of the new law, Mayor Jackson felt that women should also be considered for appointments within city government

and announced the creation of a new position within the police department: police matron.[175] Amidst a growing population, the police matron was asked to provide assistance to the women and young girls of the city. Her initial duties were to look after the social welfare of girls in the city and investigate housing conditions. Although the police matron was not given powers of arrest, she was given the authority to send violators to the police or have officers called when needed. Miss Edith McCully, a graduate of Cornell University, was selected to fill the position. McCully had experience as a social worker at reformatories in Bedford, Massachusetts, and in San Francisco and had also worked as a probation officer in Hamilton, Ohio.[176] Regrettably, on October 22, 1917, after only two months, she resigned. The position remained vacant for seven months before a replacement was found. On June 1, 1918, N.E.L. Austin was appointed to be Burlington's new police matron. Austin was initially hired on a three-month trial basis but quickly proved herself worthy of a permanent appointment, which she would hold for the next twenty-one years. In her first six months, Austin visited 195 homes, conducted interviews with twenty-two female inmates and placed many runaway girls in more permanent homes.[177] She also housed nine previously unsheltered women at the police station and helped enforce the curfew law for juveniles by patrolling the streets of Burlington, both day and night. She also provided escorts for

Police matron N.E.L. Austin. She would later become the department's first policewoman in 1920. *The Burlington Police Department.*

many elderly women of the city to and from the train station. In addition, Austin volunteered as a nurse at the Ethan Allen Club during the Spanish influenza outbreak of 1918 that devastated the local population.[178] For her tireless efforts of commitment and self-sacrifice, she was paid the meager salary of $900 a year.[179]

THE INSANITY OF HARVEY F. MOONEY

On May 12, 1918, Harvey F. Mooney of 32 School Street was taken to the Corbin & Frye funeral parlor "with his throat cut from ear to ear."[180] Mooney's morbid endeavor started when he entered a vacant tenement house on Cherry Street earlier that day. A witness saw Mooney enter the building and summoned Officer John J. Splain to investigate.

Officer Splain proceeded to the rear of the building and found Mooney standing on the first landing of the stairs. After a brief encounter, Mooney turned and rushed up the stairs to the attic. On the upper level of the building, Mooney hid behind the chimney and began slashing his wrists with a razor. Officer Splain followed in pursuit but was unable to see Mooney until he was within a few feet of the chimney. It was then that Mooney put the razor up to his own neck. In an attempt to stop the suicidal man, Officer Splain lunged forward and grabbed Mooney's arm. While the two men wrestled, Mooney drew the razor blade across his own throat, severing his trachea. Splain continued to grapple with the man on the floor until Mooney lost consciousness. It was reported that the "blood from the jugular veins was spouting onto the floor in streams."[181]

With Mooney bleeding severely, Officer Splain rushed to the alarm box in front of the Sherwood Hotel and notified Chief Russell of the incident. Within minutes, the police automobile arrived and rushed Mooney to the hospital, where he was later pronounced dead. Mooney's wife was shocked by the news and stated that her husband had seemed well that morning. Mooney was survived by his wife and two children.[182]

ON JANUARY 16, 1919, the National Prohibition Act, known as the Volstead Act, took effect, making the manufacture, transportation and sale of alcoholic beverages illegal in the United States.[183] Although federal revenue and customs officers were the primary arm of enforcement for the new law,

the officers of the Burlington Police Department would be asked to do their part in its enforcement.

The end of World War I and the implementation of Prohibition presented a mix of welcome changes and new challenges for the police matron, N.E.L. Austin. She noted that "boys returning from overseas and from the various camps made many joyful occasions, which very often were not tempered by reason, making necessary the patrolling of the streets and chaperoning of the public places."[184] In a testament to the wide scope of her duties, Austin also reported on the issue of venereal disease. She promoted the use of the free clinic in the city where patients could be treated and applauded the Vermont law that prohibited people from getting married while infected with a venereal disease. The first case under the law was tried in Burlington, and the defendant, a woman, was convicted and sent to the state prison in Windsor, Vermont. The woman was not discharged from prison until she was cured of the disease.[185]

The Trial of Edward T. Daley

The trial of Edward T. Daley, who was charged with striking and killing Miss Hazel Rugg with his automobile in September 1919, drew considerable attention from the citizens of Burlington and was the result of one of the most infamous motor vehicle fatalities in the city's history. The case would validate the early efforts of law enforcement and solidify the need for increased motor vehicle enforcement in the future.

On September 17, 1919, Miss Hazel Rugg, a twenty-nine-year-old woman of the city, was struck and killed on Shelburne Road. Edward T. Daley, a taxicab driver, was subsequently arrested by Officer Collins and Officer Miles of the Burlington Police Department. The police investigation found that Miss Rugg had left her home on Clymer Street at eight o'clock that night, intending to take the electric trolley car to the southern part of the city. It was reported that Miss Rugg began crossing Shelburne Road but unexpectedly changed her mind. The conductor of the trolley car watched as Rugg turned back toward Clymer Street, as if she had forgotten something at home. A second later, both the conductor and the motorman saw a speeding automobile heading north, followed by the sound of the crash. The northbound trolley was the first to reach the scene of the accident and found Miss Hazel Rugg's lifeless body approximately seventy-five feet north

of Clymer Street. Later that evening, an automobile belonging to Edward Daley was found on the street with a piece missing from the mudguard. The missing section matched the mudguard that was found at the scene of the accident. Daley also admitted to operating the vehicle around the time the accident occurred. At his arraignment, Daley pleaded not guilty to the charge of manslaughter.[186]

At trial, the motorman of the southbound trolley car testified to hearing the crash and estimated that the car that struck Miss Rugg was traveling "not less than 50 miles an hour."[187] In addition to the automobile's speed, witnesses stated that the car that struck Miss Rugg did not stop and fled from the scene with its lights extinguished. As the trial continued, Chief Russell testified that the mudguard that had been presented as evidence matched the missing mudguard from Daley's automobile. He also testified to other items that were found at the scene, such as Miss Rugg's shoe, which was found near the trolley tracks a short distance away from her body. At the close of the trial, Judge Mower instructed the jury on its obligations and stated that although Miss Rugg may have acted in a careless manner while crossing the street, her actions did not relieve Daley of his responsibility to operate his automobile in a responsible manner. In the end, the jury found Daley guilty of manslaughter, and he was sentenced to no less than four years and no more than five years of hard labor at the state prison in Windsor.[188]

THE BRAWLING MS. MAY BEE

On the morning of October 22, 1919, Fred Monette was preparing to marry the woman he loved, Ms. May Bee of Battery Street in Burlington, Vermont. Before the two could exchange vows, the ceremony was interrupted by officers of the Burlington Police Department. Much to the surprise of the groom, the officers arrested his bride on two warrants for breach of peace. Instead of enjoying their honeymoon, Mr. Monette was desperately trying to get his bride-to-be out of the Chittenden County Jail.

May Bee had been widowed in the previous year, having lost her husband during the influenza epidemic, but she met her fiancé, Fred Monette, in the days before her arrest. Ms. Bee was well known by the police for her use of "vile language" and her reputation for fighting with residents in her neighborhood.[189] In the weeks before her wedding, officers went looking for Bee at a downtown residence. She proceeded to jump out the window and

escaped through the lumberyards. A week later, Ms. Bee was once again found amidst a brawl on Battery Street involving a dozen or so other subjects. When police arrived, she again disappeared. It was reported that "she got wind of the doings and started to run and has the ability to lift her heels like a deer."[190]

Police learned of her whereabouts and the scheduled wedding through the marriage license application that Monette had filed. Officer Sinon took May Bee to the county jail while Monette asked for clemency from Judge Ladd. He enticed the court by offering to take his fiancée out of town as soon as possible.[191]

A TUMULTUOUS DECADE (1920-1929)

In 1920, cases of intoxication and dependent children were on the rise, and the workload placed on the police matron was substantial. In that year, Austin took on several young women who had come to Burlington looking for work only to be left jobless and walking the streets. Austin also attended a meeting with other matrons and protective workers in Boston, Massachusetts, where she met with the first lady, Mrs. Calvin Coolidge. Upon returning to Burlington, Austin used her increased responsibilities and tireless work ethic to move the rights of women one step closer to equality. In February, she petitioned that the city change her title from police matron to policewoman. In light of her undeniable merits, the change was adopted, and the department became one of the first in the nation to officially recognize the rank of policewoman.[192]

A Suicide on Lake Champlain

By January 1920, Mrs. Scott had been at the Lake View Sanitarium for an uneventful two months, haunted by mental illness. One morning, while walking through the grove behind the sanitarium accompanied by her attendant, she suddenly made a dash toward the ice-covered lake. Her attendant helplessly watched as Mrs. Scott plunged beneath the frozen waters of Lake Champlain. When the police arrived, they looked

out over the lake and spotted the hole where she had fallen through. It was nearly one hundred yards away from shore.

It was clear that Mrs. Scott was dead, but in the interest of providing a proper burial, the officers attempted to recover her body. Under this obligation, Sergeant Ryan and four other officers went out onto the ice. The officers followed Scott's footprints in the snow, carrying a rowboat in case the ice gave way under their feet. As they neared the hole in the ice, it became apparent that if they proceeded any farther they would all share the same fate as Mrs. Scott. Officer Collins stepped forward and volunteered to go on alone. With his fellow officers nearby and the rowboat at the ready, Collins slowly walked toward the opening in the lake. He was able to position himself close enough so that he could see Mrs. Scott's lifeless body. The cold air of January had already formed a thin layer of ice over the hole and her rigid corpse. Officer Collins broke through the ice with a hand hook and carefully pulled Mrs. Scott's body from the cold water. With the ice cracking beneath them, the officers loaded Mrs. Scott's body into the rowboat and carried it to shore, where it was transported in the police ambulance to Gurney's funeral parlor.[193]

"Peeping" Henry Bedard

After a long and persistent investigation, the officers of the department were finally able to capture the elusive Henry Bedard. In the early weeks of September, the city was plagued by a rash of "Peeping Tom" complaints, and the notorious peeper who had eluded police for the better part of the year was gradually escalating his activities. With each new complaint, Chief Russell carefully documented the date, time and location of the event. It was not long before a pattern emerged, and a trap to catch the peeper was carefully set.

On September 9, 1920, three policemen were sent into the woods off Mansfield Avenue and patiently waited for Bedard to appear. As the sun began to set, Officers Sinon, Collins and McGaughan observed a man walking through the woods toward the Mount Saint Mary's Academy, where he began peering in the windows. Under close surveillance, the man retreated into the woods, where the officers were waiting for him. In the seclusion of the trees, the officers surrounded the man and placed him under arrest. He was identified as Henry Bedard, and police learned that he had constructed

Mount Saint Mary's Academy. *Special Collections, University of Vermont Libraries.*

a hut nearby, made out of tree boughs, in which he had fashioned a number of peek holes. It was through these peek holes that Bedard would watch the young girls of the academy when they were on the playground.[194]

Bedard later confessed to Chief Russell that he had been peeping in windows in various parts of the city and most often frequented the streets of Brookes Avenue, North Willard Street, Isham Street, North Prospect Street, Colchester Avenue and Mansfield Avenue. It was difficult to capture Bedard because he was young and active and had spent time in military service. It was said that he knew the rear entrance to every yard in the city and had many hiding places.[195]

IN 1922, THE NUMBER of regular police officers was reduced to nineteen, and the once heralded police automobile, the first in the fleet, was in horrible condition. Through the efforts of Chief Russell, the department acquired two motorcycles that were of great assistance in the enforcement of motor vehicle violations.[196] Both motorcycles had sidecar attachments, and in the following year, officers were individually selected as motorcycle patrolmen. In 1923, Officers Joseph F. Vincent, Albert J. Gutchell, Henry E.

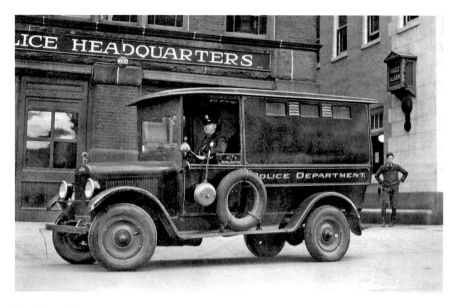

The Black Mariah, a combination patrol/ambulance used by the police department during the 1920s. *The Burlington Police Department.*

Bousquet and Arthur J. Limoge were selected to be the inaugural members of the Burlington Police Department's motorcycle unit.[197] The department also acquired a paddy wagon–style patrol ambulance that was capable of transporting injured victims to the hospital or dead bodies to the morgue. Its shielded cargo compartment could easily transport a half dozen prisoners or a handful of drunks. With its black-painted finish and low, growling engine, it was not long before the officers of the department fondly named the automobile the Black Mariah.

By December 1922, public sentiment over Prohibition and the overall ineffectiveness of its enforcement drew harsh criticism from the prohibitionists of the city. Temperance supporters began pressuring local politicians and accusing law enforcement of intentionally overlooking violations of the liquor law.[198] Under such criticism, Chief Russell had no choice but to double the ongoing efforts of the department whether or not he had the resources to effectively do so. In the days that followed, a headline from the *Burlington Free Press* read, "Chief Patrick Russell Gives Order to Police to Report Immediately All Places on Beats Suspected of Harboring Sellers of Booze."[199] It was said that the city of Burlington was in the clutches of an "Illicit Liquor Ring" and that arrests for drunkenness were 30 percent greater than in the "Damp Days" of 1918.[200] The chief's

orders spread through the "mysterious channels of the underworld" and wreaked havoc among "the high privates and captains of John Barleycorn's army."[201] Many attributed the increase in intoxication to the falling prices of illegal liquor that was in abundance in the city. Prohibitionists searched to find reasons for the blatant and public consumption of liquor, and some citizens even accused the police department of covering up the problem of drunkenness. They claimed that officers were hesitant to arrest a person for intoxication because each arrest counted "as a black mark against the record of their efficiency."[202] This presented an impossible situation. If an officer made arrests for intoxication then he would be criticized for not being efficient in controlling the illegal trade. In contrast, if the officer did not make an arrest for intoxication, he was accused of being derelict in his duties. Some citizens sent a proposal to Mayor Jackson requesting that action be taken against the officers of the department. The proposal requested that

> *if raids are conducted by federal or State officers or members of the Burlington police department, other than those officers on the beat, and alcoholic liquors are seized in any building that has not been reported by the officer whose beat it is located, and a conviction follows, the officer will be forthwith suspended.*[203]

Mayor Jackson refused to sign the proposal and reinforced his confidence in the officers of the department, stating that it was unfair to expect officers to know every place that liquor was being sold. Mayor Jackson fired back at the prohibitionists, stating that he had seen strong support for legal liquor within the city and very little public sentiment for the enforcement of prohibition.[204] If his statements were accurate, the prohibitory push in 1922 may have been the loud and boisterous shouts of a minority in the city.

Unfortunately for Mayor Jackson, the prohibitionists found support for their cause in the days that followed his address. On a quiet Sunday morning, a crowd of drunken students from the University of Vermont came piling into one of the local restaurants on Church Street. The students began wrestling and soon took to the food counters, throwing custard and pumpkin pies at one another. The mêlée was interrupted when they saw a Burlington police officer arresting a fellow student for intoxication. The mob attacked the officer and attempted to free his arrestee. The officer was injured during the attack but was able to maintain custody of the man and place another member of the mob under arrest. The drunken students nearly destroyed the restaurant, and the event was used by the prohibitionists to criticize the

mayor and accuse the police department of further ineffectiveness. They claimed that if the police had been more vigilant in enforcing the liquor law then the students would not have been able to access illegal liquor.[205]

THE ASSAULT OF FLORENCE MOODY

On September 3, 1922, Florence Moody was taking an afternoon walk through Battery Park when she was approached by a man named Albert Delisle. He had been lingering in the park for sometime, but unlike other parkgoers, he had nefarious intentions. Seeing Ms. Moody walking unescorted, Delisle cautiously approached. Without warning, Delisle grabbed Moody and carried her down into the bushes along the west bank of the park. A witness called police headquarters, and within minutes three police officers came charging down the steep embankment. Halfway down the slope, an officer found Ms. Moody lying in the bushes unharmed. She gave the officers her account of the incident and provided them with a description of her assailant. As the officers searched for her attacker, a man was seen rushing through the bushes at the bottom of the embankment. One officer drew his weapon and ordered the man to stop, but the warning only made Delisle run faster. The officers raced to the waterfront, where they found Albert Delisle sweating profusely. Between heavy breaths, he professed his innocence and said that he had been sleeping in the bushes when he heard the girl's cries for help. Delisle was later identified by Moody and two other witnesses as the assailant. Delisle was well known in police circles and was arrested in 1920 for being a military deserter out of Fort Dix. He had also served time at the state prison in Windsor for "robbing an Indian."[206]

STALKS OF WHEAT BEFORE A REAPER

On June 10, 1923, the sidewalks and streets of Burlington were busier than usual as citizens gathered for the Shriner's parade. City Hall Park was a natural attraction for parents, while the children of the city lined the streets, preferring a closer view. One by one, the cars of the parade passed through the intersection of Main and St. Paul Streets, interrupted only by marchers and musicians. Moments after the last parade car passed by the Van Ness

An overturned automobile at an intersection of Upper Main Street, circa 1920. *Special Collections, University of Vermont Libraries.*

Hotel, tragedy struck. Without warning, an automobile came barreling through the intersection and spun wildly out of control. The automobile jumped the curb and slid into the nearby crowd, knocking over three young girls who were standing on the corner.

Pauline and Loretta Peeters and Gladys Fondry, all under the age of nine, were standing in the crowd when the automobile operated by Jed Martin came barreling toward them. It was said that although Martin was behind the wheel, the machine was guided purely by Canadian booze.[207]

Martin had been driving north on St. Paul Street when his automobile collided with a car driven to Dr. McSweeney, but the crash did little to stop Martin's speeding vehicle. Onlookers watched as Martin's automobile jumped the curb and knocked all three girls to the ground before coming to rest against a street lamppost. It was reported that the girls were "mowed down like stalks of wheat before a reaper."[208] Several women in the crowd fainted at the sight of the girls being struck, while others were overcome by a different emotion. Police officers rushed to attend to the injured girls, while others hurried to escort Martin to the police office, away from a crowd of infuriated citizens.

The Fondry girl was transported to her home, where it was determined that her injuries were minor in nature, consisting mainly of facial bruises. As for the Peeters sisters, they were both rushed to the hospital but were miraculously found to have sustained only minor injuries. Dr. McSweeney also exited his crippled automobile uninjured. Being a physician and having witnessed the crash, he believed that all three girls had been killed.[209]

A bottle of liquor was found in Martin's automobile, and he was arrested for breach of peace. Subsequent investigation found that Martin had been attending a party in Alburg, where he obtained the bottle of liquor before coming to Burlington.[210]

The Ku Klux Klan Burglary

In the early hours of August 9, 1924, three burglars crept through the darkness toward the Cathedral of the Immaculate Conception. They passed along the exterior walls of the church trying to find a way into the old cathedral, unaware that several maids were asleep in the neighboring building. The maids, who had been employed to clean the rectory, were awakened by the plotting burglars and alerted Father Gillis. The priest exited the rectory and saw a flashlight moving from behind the vestry window of the cathedral. He quickly called the police, and moments later Officers Sinon, McGowan and Limoge arrived at the scene. The officers rushed toward the vestry and met the burglars as they exited the cathedral. Surprised by the officers, the burglars fled on foot. One of the burglars ran toward Saint Paul Street, while the others ran north to Pearl Street. Officer Sinon closed in on one of the suspects in the area of Champlain Street and yelled for the man to stop, but his commands were disobeyed. He then fired five shots at the fleeing suspect and watched as the man stumbled to the ground. Just when it seemed that Officer Sinon had gotten his man, the burglar jumped to his feet and disappeared into the darkness. Officer Limoge pursued one of the suspects westward, where he found the man hiding in the tall grass along the west bank of Battery Street. The man was arrested and taken to jail.[211]

In the aftermath, police learned that the burglars had stolen holy vestments and candles, most of which were discarded during the chase. The nature of the burglary puzzled investigators. Why would thieves go through so much trouble in order to steal vestments and candles? Similar questions were being asked by the citizens of the city, and soon a large crowd gathered around

police headquarters hoping to learn the identity of the man in custody. His name was William McCreedy, but it was not his name that outraged the parishioners of the cathedral; rather, it was his affiliation that stirred their outrage. McCreedy was a member of the "Invisible Empire," more commonly known as the Ku Klux Klan.[212]

During questioning, McCreedy claimed that on the night before the incident he had met with two associates, Mr. Moyers and Mr. Wells, both well-known members of the Ku Klux Klan. After a night of driving around the city, McCreedy returned to his office in the area of Main Street and Church Street and was separated from his friends. He claimed that while out on an early morning walk to escape the unbearable heat of August, he happened to find a comfortable place to rest in the grass along Battery Street. It was there that Officer Limoge happened upon him and placed him under arrest.

At arraignment, even McCreedy's attorney admitted that the nature of the burglary was a serious matter but argued that McCreedy should go free because "the presumption of innocence was wrapped around the man like a garment."[213] It was an interesting choice of words to defend a man who had stolen holy vestments. The state's attorney, E.M. Horton, argued that bail should be set at $5,000, stating, "This man [McCreedy] is charged with a worse offense than breaking into a house in which persons are sleeping. The act was an interference with the fundamental principle of religious liberty."[214] Judge C.P. Cowles took both arguments under advisement and set McCreedy's bail at $5,000.[215]

McCreedy was returned to jail, where he again proclaimed his innocence, but his hopes of winning over a jury were dashed with the arrest of his one of his co-conspirators, Gordon Wells. Wells was a known Klansman, and upon his arrest he gave a full confession. Wells told police that on the night of the burglary he met with Moyers and McCreedy in Ethan Allen Park. Moyers claimed to know of a stockpile of weapons in the basement of the cathedral that included guns, ammunition, war materials and an enormous quantity of deadly acid—"enough to kill nearly all the inhabitants of New England."[216] Wells went on to tell how he and McCreedy did not believe Moyers, and they all agreed to break into the church to find out the validity of the story. Once inside, they learned that Moyers had misled them and that he had staged the burglary in order to stir up local criticism against the local Klan leader, with whom he had a personal feud.

In the days following the burglary, Moyers fled in the company of allied Klansmen who were attending a meeting in Concord, New Hampshire.

From there, he traveled to Rochester, New York, in order to avoid arrest. Detectives relentlessly pursued Moyers from New York to New Market, Tennessee, where on August 19 he was arrested for his role in the cathedral burglary. Moyers was later delivered back to Vermont, where he was found guilty and sentenced to serve a minimum of two years in the state prison at Windsor. With his conviction, the outrage surrounding the incident slowly evaporated, but the sinister agenda of the Ku Klux Klan was still at work. In a secretive political maneuver, Moyers, a ranking member of the Ku Klux Klan, was inexplicably pardoned by Governor Franklin S. Billings. He was released from prison in August 1925, a year shy of his minimum sentence. To add further suspicion, the pardon was conducted in secret and against Vermont law, which required that any pardon application be examined by the state's attorney. The governor not only failed to give a reason for the pardon, but also the state's attorney, Ezra M. Horton, was never notified of Moyer's pardon application or his release from prison.[217]

IN THE EARLY DAYS of January 1925, it was readily apparent that the year would be an eventful one. On January 2, Chief Russell and Policewoman N.E.L. Austin were called to the home of Mrs. Fountain. Upon their arrival, they were presented with a two-week-old baby boy. Earlier that day, a man by the name of William Jerry had been walking near the Winooski River when he heard a strange noise coming from beside the water. He thought nothing of it at the time, but on his return trip later that day he again heard the strange noise. After searching the area, he discovered the abandoned baby lying along the banks of the river. Unsure of what to do, he brought the baby to Mrs. Fountain, who lived nearby. The child was wearing a white dress, booties and silk socks and was found wrapped in a woolen blanket. Police officers returned to the area where the baby was found and recovered a pacifier, but there were no signs of the baby's mother. The child was found to be unharmed, despite the cold of January, and was placed in the care of a local nurse. It was suspected that the child's mother had cast herself into the raging waters of the Winooski River.[218]

The police department also found a new home that year—or more accurately, it occupied an old one. The Ethan Allen Fire House on Church Street had served the fire department since 1888, but in 1925 the fire department was given a new firehouse. Upon its departure, the police department moved into the old fire station, where it would stay until 1967.[219] The old building was a welcomed change from the basement office of city hall.

HISTORIC CRIMES AND JUSTICE IN BURLINGTON, VERMONT

A winter view of Church Street, circa 1925. *Special Collections, University of Vermont Libraries.*

It was also in 1925 that Chief Patrick Russell was entered into a popularity contest sponsored by the *Police Journal,* published out of New York. To anyone who knew him, it was no surprise when it was announced that he had won. The prize was a "shot-proof" vest.[220] Such an innovation was a true gift, and nearly six decades would pass before such vital protective equipment would be available to the patrolmen of the department.

The year was also marked by the addition of another woman to the ranks of city government. At the age of twenty-seven, Miss Consuelo Northrop became the first woman to be elected grand juror in New England. She would later serve the state as a representative and a senator. In her lengthy political career, Northrop ran for office twenty-four times and never lost an election.[221] With all of her future accomplishments ahead of her, in 1925 Northrup embarked on the bold and simple pursuit of justice, prosecuting the cases brought to her by the officers of the Burlington Police Department.

A Murderous Assault on Sheriff Todd

On January 4, 1926, the *Free Press* printed a headline that spread panic throughout the city: "Prisoners Assault Sheriff Todd and Escape from the County Jail."[222] The incident occurred on the evening of January 2 and began when a man came to the county jail seeking shelter from the cold. Sheriff Todd agreed to take the man in and escorted him to the holding cells. When he opened the cell doors, one of the prisoners, Wilmer Symmonds, rushed out and struck Sheriff Todd in the head with a wooden club. Todd fell to the ground but continued to fight with Symmonds until he was beaten unconscious. Symmonds quickly escaped the jailhouse, having memorized its layout from the previous day when he had been photographed by immigration agents. Another prisoner, Henry LaPierre, also escaped, but LaPierre was not as prepared as Symmonds. He quickly became lost in what seemed to be a labyrinth of rooms and hallways. LaPierre finally smashed out a window and jumped out onto Main Street, where he met up with Symmonds. Having forged an alliance, the two men hijacked a milk truck and escaped to South Burlington.

As for Sheriff Todd, the tenacious old lawman got to his feet and washed his blood-covered face. Dr. Sabin hardly had time to stitch up the gash on Todd's head before the sheriff began his pursuit. Officers were sent out on foot, while motorcycle officers patrolled the roadways surrounding the city. Immigration agents and the Canadian border authorities were notified as constables, deputy sheriffs and police officers from around Chittenden County converged on Burlington.

Wilmer Symmonds had been jailed for illegally boarding a Central Vermont Railway train. He was serving a thirty-day sentence, and immigration officers were applying to have him deported. His fellow jail breaker, LaPierre, who was said to be "weasel-faced," was held on burglary charges and was wanted by Massachusetts authorities.[223]

The violent nature of the assault on Sheriff Todd and the fear that the convicts might strike again weighed heavily on the minds of Burlingtonians. It also fueled the efforts of law enforcement officers whose around-the-clock patrols would soon bear fruit.

On the night of January 4, a citizen reported seeing two men matching the descriptions of LaPierre and Symmonds walking on the Lower Road, on what is now Riverside Avenue. When officers arrived, they saw a man walking between the St. Joseph's cemetery and the Reeves lumberyard. Officer Vincent waited by the retaining wall as the man approached. Vincent then pointed his

HISTORIC CRIMES AND JUSTICE IN BURLINGTON, VERMONT

Riverside Avenue near the Salmon Hole, circa 1930. *Special Collections, University of Vermont Libraries.*

flashlight at the man and immediately recognized him as LaPierre. Officer Vincent quickly drew his revolver and took LaPierre into custody. Believing that Symmonds had run down into the Intervale, police officers surrounded the area, and bloodhounds were called on to pick up his trail.

By the fourth day, the search party had swelled to twenty-five officers and volunteers who were working day and night to track the remaining fugitive. Since the pursuit began, they had walked nearly ten miles in and around the city of Burlington.

On January 7, at the Williston railway station, a man matching Symmonds's description was seen entering a handcar shed. A group of railroad hands notified Constable Dennis Kendrew of Williston, who was joined by Chief Dewey Perry of Essex. With revolvers drawn, the two lawmen entered the shed and caught Wilmer Symmonds by surprise. Symmonds surrendered without incident and was transported back to Burlington.

The six-day manhunt was over, and in his prison cell Symmonds was forced to confront Deputy Sheriff T. Howard Todd, the son of the injured sheriff. Symmonds was quick to apologize for attacking Sheriff Todd and stated that he had not intended for anyone to get hurt. He continued, "I made a mistake. You can't beat the law these days."[224]

After Symmonds's capture, authorities learned more about the escape and the manhunt that followed. Symmonds admitted that he and LaPierre

had pre-planned the escape and had waited for a time when Sheriff Todd was alone to carry out their scheme. Symmonds also said that once on the run, LaPierre proved to be difficult, and at one point, Symmonds had to drag him by the hand. He also told how officers nearly caught him in the Intervale and forced him to spend much of the night in the cold waters of the Winooski River. After wading to safety, Symmonds was unable to build a fire and slept in soaking wet clothes. Toward the end of the chase, Symmonds planned to go to Boston, where he would enlist in the navy.[225] In order to reach Boston, he attempted to catch a train in Williston, which ultimately was his undoing.

On March 24, 1926, Henry LaPierre and Wilmer Symmonds were brought to trial on charges of breaking jail and assault with intent to kill. The jury deliberated for only one hour and returned with a guilty verdict. On March 25, 1926, Judge Frank L. Fish sentenced LaPierre to twenty-five to thirty years in prison. For LaPierre, a man in his forties, it was a life sentence. A key factor at sentencing was LaPierre's lengthy criminal record, which dated back to when he was thirteen years old. As for Symmonds, although he carried out the malicious attack on Sheriff Todd, he had no known criminal record. Judge Fish felt that Symmonds had been poorly influenced by his criminal companion and hoped that he could one day return to society as a law-abiding citizen. Symmonds was sentenced to a five- to ten-year prison term.[226]

A Tragedy on Church Street

On the quiet afternoon of March 2, 1926, Philip Heed walked into the Green Brothers store on Church Street, where his wife, Mrs. Beatrice Heed, was working. Without warning, he drew a .32-caliber Harrington and Richardson revolver and shot his wife three times in the back, dropping her to the floor. Heed then raised the gun to his head and pulled the trigger, falling to the floor just a few feet away from his wife. Officers Gutchell and Bousquet arrived moments later to find their bodies lying on the floor of the store. Amazingly, both were still alive. Mr. Heed, who was still able to speak, requested that the officers get a doctor for his wife. The officers lifted the couple from the pool of blood on the floor and loaded them into the police ambulance. Mr. Heed was overheard speaking to his injured wife: "I'm sorry I did it, Beatrice; you know I love you."[227]

HISTORIC CRIMES AND JUSTICE IN BURLINGTON, VERMONT

Church Street looking south, circa 1930. *Special Collections, University of Vermont Libraries.*

The couple was rushed to the hospital, where it was determined that Mrs. Heed had sustained three bullet wounds to her back, one of which had passed through her back and exited below her left collar bone. The bullet was found trapped in her clothing. Another bullet was lodged near her spine, and the third was found lodged near her right lung. The bullet in Mr. Heed's head had entered just below his right ear and passed below his brain, coming to rest beneath his left eye.[228] Both Mr. and Mrs. Heed passed the night at the hospital in very serious condition, and doctors were unsure if either would live.

The police investigation found that on the previous Saturday, Mrs. Heed had been in an argument with her husband over his unsteady employment at the Woolen Mill in Winooski and his refusal to look for another job. After the argument, Mrs. Heed met with an attorney and was considering filing for divorce. While many debated whether Mr. Heed's motives were premeditated or driven by uncontrollable passion, police uncovered a telling piece of evidence. On the morning of the shooting, Mrs. Heed had called the laundry service requesting a pickup, but when the laundry truck arrived, Mr. Heed told the driver that it was no longer necessary for the laundry to go out.[229] Dead people have little use for clean clothes.

After nearly a week in the hospital, Mr. Heed was taken to the county jail and was charged with the attempted murder of his wife. His trial was brief, and Judge Sherman R. Moulton sentenced Heed to serve twenty to twenty-five years with hard labor at the state prison in Windsor. Mrs. Heed would go on to make a full recovery, and in 1927 she was granted a divorce from the man who had tried to kill her.[230]

IN NOVEMBER 1927, the city of Burlington was forced to deal with the unexpected fury of Mother Nature that led to the Great Flood of 1927. In early November, Vermont was bombarded by a series of torrential downpours, and in just two days, Burlington received over five inches of rain. The results were catastrophic.[231] Some of the worst flooding occurred throughout the Winooski River Valley, where the raging waters carried away bridges and washed away railroad lines. Although Burlington fared better than other areas, many families were forced from their homes and appealed to the police department for help. Despite the disruption of roadways, bridges and telephone lines, Policewoman Austin and the other

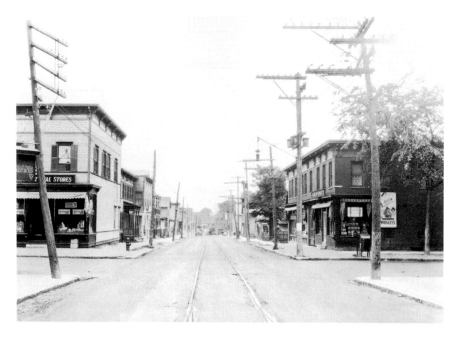

North Street at the intersection of North Champlain Street looking west, circa 1925. *Special Collections, University of Vermont Libraries.*

HISTORIC CRIMES AND JUSTICE IN BURLINGTON, VERMONT

South Union Street looking north, 1928. Tragically, the iconic church steeple in the background would be burned by an arsonist in 2013. He was arrested at the scene by officers of the Burlington Police Department. *Special Collections, University of Vermont Libraries.*

A back alley of Burlington, Vermont, circa 1930. *Special Collections, University of Vermont Libraries.*

officers of the department helped many people find shelter and food until they could return to their homes. The entire city was cut off from the outside world until the rain stopped and the floodwaters receded. In the end, the flood had claimed eighty-four lives statewide and inflicted over $20 million worth of damage.

In 1928, the police department welcomed an important shift in tactics. It was the first year that officers were assigned to patrol automobiles. The policemen selected to operate the automobiles were Officers Clarence E. Weston, Frank J. Medler, Levi Vincent, Joseph F. Vincent, John H. Francis and Albert J. Gutchell.[232] Although the department had been utilizing automobiles for several years, it had never had such a fleet at its disposal. It was a substantial step away from the foot patrols of the previous decades and would have a profound influence on the evolution of the police department.

In 1929, as the decade came to an end, Policewoman Austin outlined what she felt was the greatest challenge facing society. In hard economic times, with the city crippled by unemployment, she proclaimed that "work is the great stabilizer of humanity."[233] Her words carried a prophetic message and painted a desperate forecast for the years ahead, as the city and the nation entered the Great Depression.

AT ODDS WITH CITY HALL (1930-1939)

In 1930, the Burlington Police Department, like most of the nation's larger police departments, began focusing on modern investigative theories and forensic analysis. Since 1894, Scotland Yard had used the forensic practice of fingerprint analysis in police investigations, but in America it was not until the emergence of J. Edgar Hoover and the creation of the Federal Bureau of Investigation that the practice became common. In an effort to develop such forensic techniques, Officer Henry Bousquet was chosen to represent the Burlington Police Department in this new realm of police technology. Bousquet proved to be so effective that he was nominated to become one of eight directors of the National Identification Association. Bousquet was nominated from among internationally known criminal and forensic investigators to lead the 240-member organization.[234] The honor was a testament to Bousquet's abilities as an expert in fingerprint analysis.

In 1931, the unemployment crisis showed no signs of immediate change, and Mayor Jackson asked that city departments extend their activities throughout the winter months in order to provide consistent work and pay to the city employees. The grave nature of the Depression was outlined in the mayor's annual report. "We have done our best to prevent as much suffering as possible. Let us hope that 1932 will present a brighter outlook and great improvement in this distressing situation."[235] During 1931, nearly 1,672 men received homeless lodging at the police station and were given meal tickets, funded by the charity department of the city. Although many of the

HISTORIC CRIMES AND JUSTICE IN BURLINGTON, VERMONT

Left: Henry Bousquet, chief of the Identification Bureau. Bousquet was not only the department's first expert on fingerprint analysis, but he was also the department's most skilled marksman. *The Burlington Police Department.*

Below: The Burlington waterfront and the *Admiral* and *Oneida* ferries, 1934. *Special Collections, University of Vermont Libraries.*

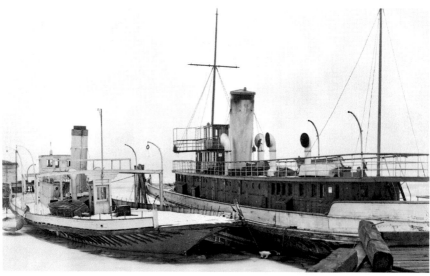

men were recognized as "chronic loafers," a great many were unemployed laborers who had come to Burlington hoping to find work.²³⁶

Amidst hard times and an increase in crime, the city of Burlington and the police department suffered two heavy losses. On February 28, 1931, Sergeant John H. Ryan, the first deputy chief of the department, died after a lengthy career. A few months later, on July 29, 1931, Chief Patrick J. Russell died at the age of sixty-four. Russell had served as a policeman from 1896 to 1903 and as chief of police from 1903 to 1931. Chief Russell was well known for being a faithful and honorable police officer, and it was said that he had an uncanny gift when interviewing suspects and excelled at obtaining confessions without resorting to third-degree methods.²³⁷ During his career, Chief Russell saw the ranks swell from twelve officers to twenty-six at the time of his death. Included among them was one of his sons, Officer Donald P. Russell, who would one day serve as chief of police. Chief Russell had also served as the president of the Burlington Police Relief and Benefit Association and worked tirelessly to raise money and relief aid for the families of the officers under his command.²³⁸

Following Chief Russell's death, Patrick J. Cosgrove was appointed chief of police, and with the approval of the state legislature in 1931, the rank of deputy chief was changed to captain, first filled by Victor Fisher.²³⁹ Recent years had brought a series of mournful losses and career retirements, and for the first time, the department was challenged with finding adequate replacements.

In 1932, the police department took in a new addition to its ranks: a stray cat. Lured to police headquarters by the around-the-clock

Chief Patrick J. Cosgrove. Cosgrove served the city and the department for forty-three years. In retirement, he was elected to the state legislature and served as an assistant judge in Chittenden County. *The Burlington Police Department.*

HISTORIC CRIMES AND JUSTICE IN BURLINGTON, VERMONT

The corner of College Street and South Winooski Avenue looking north, 1931. *Special Collections, University of Vermont Libraries.*

commotion, it was not long before the cat was taken in by the officers of the department. He was given the name Sleuth and would earn his keep by licking the dishes left by the patrol officers. However, Sleuth's time with the department was short, and in September he tragically died from ingesting a strong dose of flea treatment.[240] For those of a superstitious nature, the death of Sleuth the station cat would serve as a powerful omen of the hardships to come and the dreaded return of Mayor Burke.

In 1933, Mayor Burke was once again elected mayor. His return was marked by the political practices of the past. Burke immediately turned his focus on the police department and began restructuring the department in every way he could. He demoted officers who had been promoted by his political rivals and would have restructured the higher ranks but Captain Fisher's and Chief Cosgrove's ranks were permanent appointments and were out of the mayor's reach. Not content with restructuring the department, he seemed fixed on demoralizing it. He called a special roll call before the entire police force and unleashed a tirade, accusing the officers of being derelict in their duties and of loitering in hotel lobbies and restaurants. He accused the men of being discourteous to their superiors by not saluting and fanned the flames of discontent. The eighty-four-year-old mayor then issued a decree banning vacations with pay and stated that if three officers were able to go on vacation at one time, then he would make cuts in personnel. Hypocritically, he accused the officers of publicly engaging in politics, which he condemned. Burke stated that he knew that some officers had worked for

The Burlington Police Department, circa 1932. *The Burlington Police Department.*

other political candidates, and he warned them not to do so in the future. Burke shamed the officers, insisting that they were well paid, and warned them that the city was full of unemployed men who were qualified and eager to replace them.[241] James Burke was back in the mayor's office, and it was a bad time to be a police officer.

In the wake of Mayor Burke's reelection, three officers resigned. Under a mayor who was determined to dismantle the department piece by piece, even Chief Cosgrove applied for retirement. Although he had forty-one years of service, he was denied retirement benefits because he was found to be in good physical health and of sound mind and therefore ineligible for retirement.[242] He would be forced to bear the wrath of Mayor Burke or pray for ill health.

ARMED GUNMEN FROM MASSACHUSETTS

Two months before John Dillinger was named public enemy number one, officers with the Burlington Police Department had a run in with a trio of armed gangsters from Massachusetts. On May 9, 1934, a tip came

Detective Myer Gardner with a Thompson submachine gun, circa 1938. *The Burlington Police Department.*

into police headquarters reporting that a group of men had been visiting area gasoline stations, trying to sell stolen goods. Officers Rock, McCarty and Gardner were sent out to look for the suspicious trio. While patrolling the area of Battery Street, the officers observed the suspects' vehicle, bearing Massachusetts plates. As the vehicle approached, Officer Rock drove his police cruiser into the sidewalk, cutting off the oncoming sedan. Officers McCarty and Gardner leapt out of the cruiser with their pistols drawn. The suspects attempted to flee, but as the officers swarmed around them, the men reluctantly surrendered. The gang was made up of John Burke, Vincent Pinto and Bernard Larr, all from Massachusetts. A search of the vehicle produced a .38-caliber revolver, a .22-caliber rifle and a trunk full of several hundred dollars' worth of goods. A loaded .38-caliber pistol was found in the coat pocket of Bernard Larr, but perhaps most troubling was the fact that police found unexplained bloodstains on the floor of the vehicle.[243]

The investigation found that the sedan had been stolen from Salem, Massachusetts, and officers found a wrapper from the Vermont Baking Company, verifying that the gang had traveled to Burlington by way of White River Junction.[244] The men were fingerprinted and photographed, and with the cold resolve of hardened criminals, all refused to cooperate with the police investigation.

The stolen Lincoln sedan was then taken to the police station, and within minutes nearly one hundred people had gathered to get a glimpse of the notorious automobile. A rumor circulated through the crowd that Dillinger had been arrested in Burlington, Vermont. The rumor led to a number of inquiring phone calls to the police office, seeking confirmation. Despite the

dispelled rumors, fascination around the stolen vehicle continued to grow. Mayor Burke ordered the sedan to be moved into a nearby garage so that the growing crowd would not trample the potted flowers around city hall.[245] While awaiting trial, it was discovered that the men had given fake names. Luckily, Sheriff Paul E. Dimick recognized the men as members of a stolen car racket that he had investigated in 1932. He confirmed that Bernard Larr was also known as Frank Lupcwicz, Vincent Pinto was known as Vincent Aleksa and John Burke had an alias of William Karpensky. At trial, the state's attorney argued for an eight- to ten-year term for the second offenders and a four- to five-year sentence for Pinto, while their defense attorney, Martin S. Vilas, argued that the men were merely "joy riding."[246]

Before imposing their sentence, Judge Grout sternly pointed out that the men were repeat offenders and well beyond the class of joy riders. Grout took it a step further and said, "It is not going too far to suppose these men may get into the electric chair some time."[247] In the end, Karpensky and Lupcwicz were both handed six-year prison terms, while Pinto was given a three-year prison term for his involvement. Having been given his sentence, Lupcwicz stated, "We'll be old men by the time we get out of prison. You can just bet you won't see me around here again."[248]

IN 1935, BURKE FAILED to win reelection, and Louis Dow became mayor of Burlington. The new mayor looked to the future and began planning for a more modern building to house police headquarters. Dow felt that an ideal location would be at the northeast corner of Main Street and Winooski Avenue, near the existing county jail. The driving force behind Mayor Dow's foresight was the plain truth that the current police station was in a serious state of disrepair.[249] With a new station house still several years away, action was taken to make more room in the existing building. For decades, homeless men of the city had found food and shelter at police headquarters, but in September 1935, that policy came to an end due to overcrowding and abuse of charity. The evicted men were directed to the poorhouse, where they would have to work for their food and lodging.[250]

On November 12, 1935, after forty-three years of service, Chief Patrick J. Cosgrove's pension was approved by the retirement board. Found to be suffering from high blood pressure and diabetes, Cosgrove retired as the longest-serving member of the police force. Without notice, and for the first time in history, Mayor Dow went outside the ranks of the department and appointed John J. Harrington to be chief of police. Harrington was an

HISTORIC CRIMES AND JUSTICE IN BURLINGTON, VERMONT

City Hall Park looking toward College Street, circa 1935. *Special Collections, University of Vermont Libraries.*

inspector with the Department of Motor Vehicles and had been in charge of the Burlington district for the past eleven years. For a city plagued with motor vehicle problems, Harrington was a wise choice, but there were aspects of the appointment that ruffled many feathers within the department. First, Chief Cosgrove had asked that his retirement be kept a secret, and even Captain Victor Fisher was unaware that he was acting chief for a day. Second, Harrington's appointment made him the first nonresident to hold the office and was a clear dismissal of Captain Fisher's tested abilities.

Amidst these internal difficulties, in February 1936 Burlingtonians witnessed a much lighter side of policing in the city. In cooperation with the National Youth Administration, the police department facilitated and supervised the largest public sledding hill in the city. Maple Street from Willard to Pine Street was closed off for sledding. Despite a police presence, many citizens argued against the practice for safety reasons, forcing Chief Harrington to address the issue. Instead of closing the hill, he relocated the activities to run from Winooski Avenue to St. Paul Street. The sliding hill remained open from 7:00 p.m. to 9:00 p.m., and children were sent down the snowy street at the sound of a policeman's whistle.[251]

On May 8, 1936, after only six months in office, Chief John J. Harrington announced his resignation as chief of police. He had accepted the position with the understanding that it would be "devoid of political maneuvers,"

Pearl Street looking west from the top of Church Street, 1934. *Special Collections, University of Vermont Libraries.*

and his departure seemed to suggest that city hall was still playing political games with the police department.[252]

By this time, Victor Fisher had been an officer for twenty-four years, and having previously been a bartender, he had traditionally been assigned the task of mixing the punch for the annual policemen's ball.[253] But at the policemen's ball of 1936, one thing was different: the man making the punch was the chief of police. Fisher was named chief of police on May 9, 1936, and he wasted no time in pursuing resources for the department. He called for an expansion of the Gamewell System to the outlying areas of the city to ensure proper police coverage. He also outfitted his officers in blue whipcord fabric uniforms that were far more durable than their previous uniforms.[254] In 1937, the department acquired two new police motorcycles and a third police car. Fisher also converted the third floor of police headquarters into two detention rooms and a room for photographing and fingerprinting suspects.[255]

In September, under the strain of his position and his strenuous efforts to improve the department, Fisher fell seriously ill and was admitted to the hospital for two weeks. He had suffered a nervous breakdown.[256] He

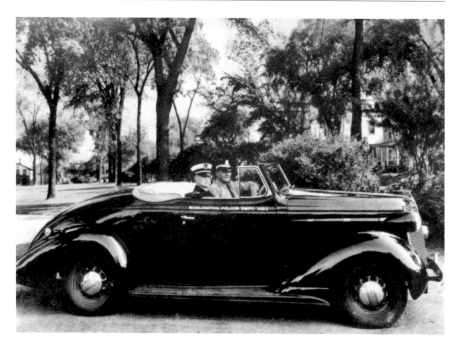

Chief Victor Fisher driven by his son, Patrolman J. Albert Fisher, in the No. 1 police automobile. *The Burlington Police Department.*

would return to his office to see charges of misconduct leveled against two of his men and a report that child delinquency in the city had reached epidemic proportions.

In 1938, the department purchased two new scout cars and a patrol ambulance and completed the construction of the Identification Unit. Fisher also implemented a card index that listed all felonies and major misdemeanors that had been committed in Chittenden County since January 1, 1925. He also installed a telephone recording system that could record all phone calls made to and from the department.[257] In August, Chief Fisher fell ill and was confined to his home. The board of medical examiners deemed Fisher physically disabled and eligible for retirement.[258] He would be remembered as an efficient leader and was well respected among the officers of the department.

On August 12, 1938, Mayor Dow once again went outside the department and chose Francis S. Regen to be the next chief of police. Regen was a former Massachusetts state trooper and had served as the chief of police in Brattleboro, Vermont.[259] Like his predecessor, Regen was intent on making the department the best it could be and worked to complete what Chief

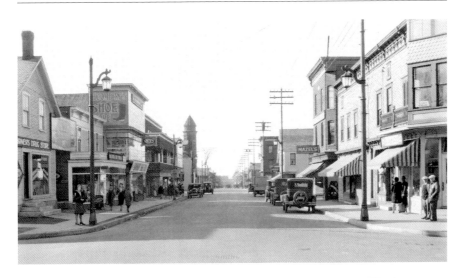

North Street looking west, circa 1935. *Special Collections, University of Vermont Libraries.*

Fisher had started. He implemented a new record-keeping system, a merit system for officers and police training classes in the fields of patrol and crime detection. Regen also assigned police officers to Burlington schools and formed a Boy Scouts program affiliated with the department.[260]

In October 1938, the department tested a fifteen-watt, two-way, ultra-high-frequency radio that was set up to communicate with a radio-fitted patrol car. By December of that year, two-way radios had been installed in all Burlington police cruisers, and James Tierney, a local radio engineer, became the department's first dispatcher. The usefulness of the police radio system was demonstrated by the fact that from December 22, 1938, to June 30, 1939, the department had produced 33,307 radio transmissions.[261]

As the first dispatcher was beginning his career, the long and successful career of N.E.L. Austin, Burlington's beloved policewoman, was coming to an end. Suffering from various ailments and having served the city for twenty years, Austin applied for pension benefits. It was determined that Austin had a physical condition that prevented her from carrying out her duties, but it was unclear if the disability had occurred while on duty. The city attorney shamefully argued that because of a recent charter amendment, Austin was not entitled to retirement benefits. In the end, reasonableness prevailed, and deservedly Austin's name appeared among the pensioned officers of the city. Austin had served the city faithfully as police matron and as its first policewoman. She also held the position of

Damage from a traffic accident, circa 1940. *Special Collections, University of Vermont Libraries.*

state deputy probation officer and was the first woman appointed as a deputy sheriff in the state of Vermont.[262]

On March 14, 1939, having served for only eight months, Chief Francis Regen submitted his resignation to Mayor Dow. He had accepted a position as the deputy state fire marshal but agreed to serve until March 31, allowing for enough time to select a worthy replacement. Although Regen did not comment on his departure, evidence suggests that the political currents of the city may have been a factor.[263]

Regen's resignation created uncertainty among the ranks of the department as they contemplated the arrival of their sixth chief of police in eight years. While the department anxiously awaited the mayor's decision, Henry Bousquet, the chief of the Identification Bureau, competed for and ultimately won the 1939 Vermont State Gallery Pistol and Revolver tournament. The competition was held in Northfield on March 18, 1939, and attracted marksmen from around the state. Bousquet won the pistol competition with a score of 710 out of a possible

The intersection of North Street and Elmwood Avenue, 1940. *Special Collections, University of Vermont Libraries.*

800 and took home first-place medals in the fifty-foot slow fire and the fifty-foot rapid fire.[264]

On April 10, 1939, from amongst a pool of candidates, Mayor Dow once again chose a chief from outside the ranks of the department: Arthur W. Thalacker. Thalacker was a member of the Westchester County Parkway Police and a graduate of the FBI Academy. He began his police career in 1925, serving as a motorcycle officer. In 1927, he received a regular police appointment and studied at the New York Police Academy, specializing in police identification work, including photography and fingerprinting. Thalacker later became supervisor of the Identification Unit in Westchester County, and in 1937, he attended the National Police Academy in Washington, D.C., acquiring additional training in investigative techniques and police administration.[265]

Chief Regen had created two new bureaus, the Investigation Bureau and the Identification Bureau, but due to his resignation, it fell on Chief Thalacker to bring them up to working order. Thalacker officially established the Identification Bureau on October 9, 1939, and

North Avenue at the intersection of Plattsburg Avenue, 1940. *Special Collections, University of Vermont Libraries.*

appointed Myer Gardner to be the first detective of the newly established Investigation Department. Thalacker also armed his officers with new Colt .38 Super Automatics, two .35 Remington rifles, a tear gas gun, gas masks and several tear gas projectiles.[266]

In May 1939, Chief Thalacker made a change to the department's radio procedures. For the first time in the department's history, all radio broadcasts would utilize police codes. Thalacker devised a system that would keep the content of the radio messages secret from those monitoring the police frequency. To do this, the codes were changed every three days and were recorded on code cards shared only with the radio dispatchers, cruiser operators and police officers.[267]

In June 1939, Chief Thalacker traveled to Washington to meet with this friend and mentor J. Edgar Hoover to study the latest developments in modern police methods. One month later, Thalacker was featured in the July 1939 issue of *True Detective* magazine. The article focused on his dedication to police education and how, while with the Westchester County Parkway Police, he had operated a police training school out of his own house, using his living room as a classroom.

The Shooting of Viola Myers

On July 18, 1939, at approximately 1:22 p.m., shots rang out from the area of North Avenue and Haswell Street. Officers raced to the scene and found Viola Myers, a thirty-five-year-old widow and mother of five children, lying on the ground with multiple gunshot wounds. Myers was rushed to the Bishop DeGoesbriand Hospital while officers scoured the Old North End for the alleged shooter, Edward Shappy, a forty-five-year-old resident of the city and a boarder at Myers's house.[268]

The investigation found that Myers and Shappy had an argument that ended when Shappy drew a .32-caliber revolver and shot Myers in the head. Amazingly, Myers was able to retreat toward a nearby residence, only to collapse in the backyard. Shappy pursued the wounded woman and fired two more shots into her head.[269]

A neighbor heard the shots and rushed to help Myers. At the same time, Shappy returned and again approached his suffering victim. He fired a fourth shot, point blank, at Myers before fleeing down the embankment off Lakeview Terrace. Police officers formed an armed perimeter around the area, believing that Shappy might try to escape on an outbound train.

The Bishop DeGoesbriand Hospital at the corner of Pearl Street and North Prospect Street. *Special Collections, University of Vermont Libraries.*

During the search, a resident of Lakeview Terrace reported seeing a man hiding in bushes behind his house and notified Officer Lavery. Officer Lavery cautiously approached and found Shappy hiding in the undergrowth, holding an empty .32-caliber revolver.[270] Shappy offered no resistance and was found to have a wound in his forehead. Authorities transported Shappy to the hospital and later determined that his injury was actually a self-inflicted gunshot wound. The bullet had entered just over Shappy's right eye and passed around his brain, lodging near his left temple.[271]

With Shappy in custody, Myers underwent surgery to remove two bullets from her brain and two more from her skull.[272] Given the extent of her injuries, Myers was not expected to survive, and on the following day, she was given a blood transfusion. After weeks of slow progress, and against all predications, Myers made a full recovery.

In the aftermath of the shooting, Shappy was sent to the hospital in Waterbury for observation. On October 10, 1939, Shappy was convicted and sentenced to no less than nine years and no more than twelve years with hard labor in the state prison at Windsor. It was said that due to the bullet in his brain, Shappy was rendered mentally diminished, with the equivalent IQ of an eight-year-old.[273]

IN THE DAYS FOLLOWING the Viola Myers shooting, police uncovered a massive crop of marijuana. Chief Thalacker and his officers located nearly fifteen tons of the plants in various parts of the city and hardly had time to burn the tonnage before another eighteen tons were found. The presence of marijuana in Burlington sent shockwaves through local government, and Governor Aiken was notified of the situation. The plants, which were estimated to be seven feet tall, were most predominantly found in the North End, and some were even found growing around houses in the city. In fact, one local woman found the plant to be quite beautiful and used it to decorate the edges of her garden.[274] The plants were so plentiful that the police department requested the help of local Boy Scout troops to assist in uprooting them. A primary concern was that most of the plants had reached a stage where their buds could have been converted to "happy weed," as it was known.[275] It was a common belief in 1939 that marijuana caused madness, and some theorized that Edward Shappy had used marijuana prior to shooting Viola Myers.[276]

The newly elected mayor, John J. Burns, asked the citizens of Burlington to help assist in the identification of the marijuana plants and arranged to

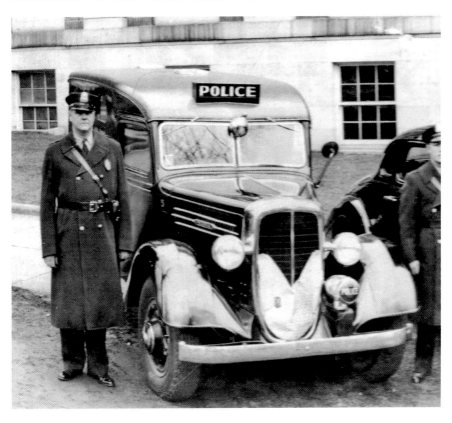

A Burlington police cruiser, 1938. *The Burlington Police Department.*

have several plants put on display in front of city hall so that citizens could more easily recognize and eradicate the leafy menace.[277] Seemingly intrigued by the plant, it was reported that Governor Aiken collected several samples for identification purposes.[278]

WHILE THE WORLD WAS AT WAR
(1940-1949)

In 1940, Thalacker was applauded for implementing a number of improvements to the fingerprinting and photographic system, as well as simplifying the record-filing system. As much as these improvements benefited the department as a whole, they also served an additional purpose. With Europe entrenched in war, the Department of National Defense was increasingly searching local departmental police records for all army and navy enlistments. The improvements to the record-filing system and identification procedures made such governmental inquiries much less cumbersome for the department.[279]

Also in 1940, Thalacker established a police training school that featured lectures and practical demonstrations on topics such as powers of arrest, how to conduct interviews, firearms training, blood identification, glass fractures and arrest restraint techniques.[280]

By November, news had spread that Chief Thalacker was leaving the department, having been offered a civil service position in Mobile, Alabama. In the months prior to its offer, the Mobile Police Department had been rocked by a police scandal in which officers were running a protection racket for bootleggers.[281] The department was desperate to find someone who could repair its fractured reputation. Given his FBI rating, Thalacker was said to be the "second best man in the country for the particular job."[282] (The quote suggests that Thalacker was bested only by Hoover himself.) After several days of consideration, Thalacker accepted the offer and submitted his resignation as chief of police.

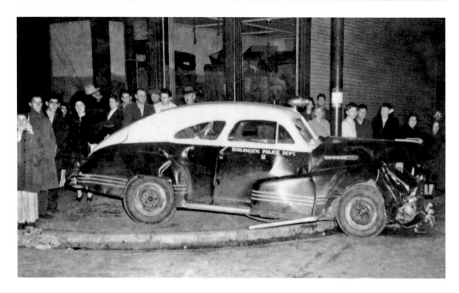

A smashed-up Burlington police cruiser, circa 1940. *The Burlington Police Department.*

Chief Frank G. Raymond. *The Burlington Police Department.*

Mayor John J. Burns announced that Frank G. Raymond would be chief of police—which was a return to the practice of in-house appointments—but the terms of the appointment were quite unique. Burns asked that Raymond sign a letter of resignation, which the mayor could present at any time should

Raymond fall short of his expectations.[283] Raymond's appointment was accompanied by several promotions and the arrival of two new policewomen, Fedora Dubrul and Priscilla Contois, in January 1941.[284]

THE CASE OF GEORGE KARPOWICH

In January 1942, a New Jersey man of unassuming appearance walked into the Burlington police station. His name was George Karpowich. Appearing quite nervous and with a heavy conscience, Karpowich asked to speak with a detective. Chief Inspector Myer Gardner agreed to meet with Karpowich, who proceeded to tell how, in the early days of January in Newark, New Jersey, he had attacked a woman with a flatiron. Karpowich told Gardner that on the night of the attack, he was intoxicated, and he had only a hazy recollection of the assault. After the attack, Karpowich attempted to enlist in the Canadian army, but he was refused. Karpowich returned to Newark for a brief time, but his paranoia and fear of being arrested only increased. He again tried to enter Canada but was turned away in Swanton, Vermont.

After hearing Karpowich's story, Inspector Gardner contacted the Newark Police Department and learned that a woman by the name of Mabel Johns had been slain in the early morning hours of January 10. She had been killed by an electric flatiron. Karpowich signed his confession, not knowing that the woman he had assaulted was dead. He was arrested for the murder and was turned over to New Jersey authorities. Karpowich's own conscience was his captor. Unknown to him at the time, Newark authorities had little to no evidence connecting him to the murder, and in fact, they had issued a John Doe warrant, desperately hoping that something would turn up.[285]

BY 1943, SEVERAL OFFICERS had resigned their positions in order to serve their country in World War II, including Chief Inspector Myer Gardner, Leonard P. Couture and Thomas J. Russell.[286] A second wave of policemen would be called up the following year, including Officers William W. Corbett, Howard W. Malaney, Raymond B. Mercure and a future chief of police Arthur J. Carron. Following the attack on Pearl Harbor, the city established a civilian defense organization as an additional line of defense should the Axis powers invade or attack Burlington. Chief Raymond was naturally placed in charge

HISTORIC CRIMES AND JUSTICE IN BURLINGTON, VERMONT

Detective Myer Gardner, chief inspector of the Investigations Bureau. In 1942, Gardner enlisted in the U.S. Army and served as a warrant officer during World War II. *The Burlington Police Department.*

of the auxiliary policemen should such an event occur, and emergency drills were regularly practiced throughout the city.[287]

On April 24, 1943, in the early hours of the morning, James Burke, the ex-mayor of Burlington, died at the age of ninety-four. In death, Burke was remembered as one of the oldest serving mayors in the United States. Despite his temper and contentious history with the police department, time had healed many old wounds. Mayor Burke's funeral procession was honorably led by the officers of the Burlington Police Department, who marched in a unison and stood watch as the old blacksmith of Burlington was laid to rest in St. Joseph's cemetery.[288] The city and the department endured an additional loss that following December when Chief John Harrington died from injuries he sustained in a car accident on Route 7 in North Ferrisburg.[289]

In 1944, the department had to alter its internal structure to accommodate the vacancies caused by the war. The deficiency in personnel led Mayor Burns to consider declaring "a state of emergency" in the city. He was forced to ignore the charter requirements for police appointments and hire any available personnel.[290]

HISTORIC CRIMES AND JUSTICE IN BURLINGTON, VERMONT

Main Street looking west, near the intersection of South Winooski Avenue, 1944. *Special Collections, University of Vermont Libraries.*

On July 7, 1945, two months after the war ended, former chief of police Patrick J. Cosgrove died. In retirement, Cosgrove served as a representative in the Vermont legislature and later became an assistant judge in Chittenden County. He was known to be an avid marksman and was a member of the Burlington Pistol and Revolver League.[291]

THE DEATH OF OFFICER J. ALBERT FISHER

On the night of December 13, 1947, Patrolman J. Albert Fisher was walking on his assigned beat in the downtown area. At 9:00 p.m., he made his way to 158 Bank Street to attend a meeting of the Knights of Columbus. Having a key to the elevator, Officer Fisher used it to open the elevator gate. When the gate opened, he step forward to board the elevator, but the elevator shaft was empty. Fisher fell four feet down into the elevator shaft and crashed on top of several large metal springs at the base of the elevator shaft. Once free from the elevator shaft, and with no apparent injuries, Fisher reported the incident to Chief Raymond.

Patrolman J. Albert Fisher. *The Burlington Police Department.*

Although Fisher insisted that he was not hurt, he was ordered to go home and rest. It was not until two days later that Fisher's health took a turn for the worse, and on the following Monday, he died.[292] Fisher had suffered a contusion of the anterior wall of his chest and multiple fractures to his left ribs, resulting in a weak and dilated heart. Fisher was a native Burlingtonian who began his career as a police officer in 1932. He was a fifteen-year veteran of the force and the son of former chief of police Victor Fisher. He was survived by his wife and son.

THE MURDER OF FRANCIS RACICOT

On March 11, 1948, an act of terrible violence shook the city of Burlington. Francis Racicot, an eighty-one-year-old harness maker, the last in Chittenden County, was found murdered in his workshop at 24 Center Street.[293] Racicot was found bludgeoned to death by a hammer. A man who tended the fires of the shop found Racicot lying in a pool of blood and notified the police. An examination found four deep gashes on the front of Racicot's head, each of which had cracked the skull.

Church Street, circa 1945. *Special Collections, University of Vermont Libraries.*

Racicot also had injuries to the back of his head, suggesting that the assault continued even after he had fallen to the floor.[294]

Four investigators were assigned to the case, and after three days had passed, on March 15, 1948, an arrest was made. The man charged with the murder was Donald E. Demag, a twenty-six-year-old from North Street. Demag had been laid off from his job and had gone to Racicot's shop to asked for a loan to help care for his child and pregnant wife. When Racicot refused, Demag struck him with an iron tool from the workshop and stole his wallet, which contained less than $100. After his arrest, Demag confessed to the murder and signed a detailed confession of the crime.[295] Demag's trial ended with his conviction, and he was sentenced to life in prison at the state prison at Windsor, but that was not the end of Demag's story.

In 1950, Demag escaped from the state prison by placing a dummy in his bunk and climbing over a sixteen-foot wall. Demag was recaptured trying to cross the border into Canada and was returned to Windsor, but he was determined to cheat his life sentence.[296] In 1952, Demag and

a fellow prisoner, Francis Blair, performed a daring escape by crashing a laundry truck through the gates of the prison. The escape resulted in one of the largest manhunts in Vermont history. Demag and Blair fled to Springfield, Vermont, where they broke into the home of Mr. and Mrs. Donald Weatherup. In a despicable act of violence, Demag and Blair beat the elderly couple with lead pipes. Mrs. Weatherup was killed, but her husband survived the attack. A posse of nearly two hundred state troopers, hunters and volunteers was sent to the area, and the escapees were eventually surrounded in the woods one mile from the Weatherups' home and taken into custody.[297]

Both men were later convicted for the murder of Mrs. Weatherup and were subsequently sentenced to death. Blair was sent to the electric chair at the Death House at the Windsor State Prison in 1954.[298] On December 8, 1954, Demag's death sentence was carried out. He was sent to the electric chair and died by the application of two thousand volts for three minutes. Demag was the last person to be executed by the State of Vermont.[299]

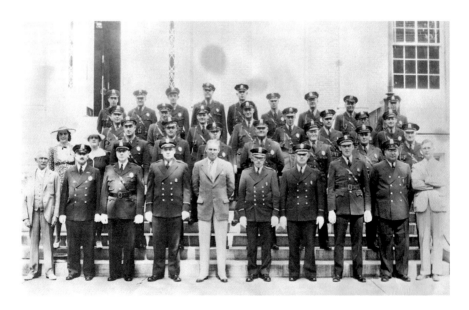

The Burlington Police Department, circa 1940. *The Burlington Police Department.*

ON OCTOBER 27, 1948, after serving eight years as chief of police, Frank G. Raymond died. In search of a replacement, the acting mayor, J. Edward Moran, turned to a seasoned veteran from within the Burlington force. He chose Donald P. Russell to be the department's next chief of police. Russell was well respected among the ranks, a graduate of the FBI National Police Academy and a pupil of Chief Thalacker's policing philosophy. He was also the son of the late chief Patrick J. Russell, one of the most respected officers in the history of the department.

THE FIRE AND A FLYING BANK ROBBER
(1950-1959)

The 1950s brought change for law enforcement across the nation. More and more police departments were consciously shifting away from the persuasion of local politics to focus on police professionalism. As the country began to settle in the years following World War II, a new ideology was

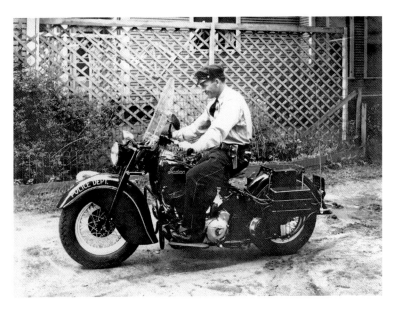

A uniformed patrolman on an Indian-brand patrol motorcycle, 1947. *Special Collections, University of Vermont Libraries.*

HISTORIC CRIMES AND JUSTICE IN BURLINGTON, VERMONT

Pine Street near the area of Flynn Avenue looking north, 1945. *Special Collections, University of Vermont Libraries.*

forming. Returning soldiers naturally gravitated toward the police profession and brought with them the strict methodology engrained in them during their military service. This created a more uniformed approach to policing that discouraged the favors of the political era by distancing police officers from the communities they served and encouraged an unbiased application of law.[300] In this respect, Burlington was well ahead of the national trend due to the innovative work of Chiefs Fisher, Regen and Thalacker, who collectively established a strong foundation for police professionalism.

THE VAN NESS HOTEL FIRE

The Van Ness House was built in 1870 on the southwest corner of Main Street and St. Paul Street and was one of the oldest hotels in Burlington. Purchased by Urban A. Woodbury, the forty-fifth governor of Vermont, in 1881, the luxurious hotel boasted a long list of famous guests, including U.S. presidents William McKinley, James Garfield, Theodore Roosevelt and William Howard Taft.[301]

Just after midnight on May 24, 1951, flames broke out on the third floor of the Van Ness House. Noticing the fire, the night watchman called for help. Lieutenant McKenzie, Officer Bergeron, Officer Croll and Detective

A Smith & Wesson Victory model, .38-caliber pistol used by the officers of the department in the years after World War II. *The Burlington Police Department.*

The Van Ness House hotel, Burlington, Vermont. *Special Collections, University of Vermont Libraries.*

Carron arrived before the fire department and rushed inside the burning hotel. The officers crawled through black smoke and rescued many guests who were unaware that the hotel was on fire. Once the upper levels of

the hotel were cleared out, the officers emerged, coughing and choking from the smoke they had encountered. During the daring evacuation, Lieutenant McKenzie cut open his hand and was treated at the scene. With all 160 guests accounted for, the fire department went to work on the blaze. Despite their courageous efforts, the blaze claimed the building, causing $300,000 in damages. The investigation revealed that the fire was caused by a cigarette and originated in the maid's lounge. Unfortunately, it was learned that a sprinkler system had recently been installed but was not yet operational.[302]

THE UVM LINGERIE RAID OF 1952

It all began on May 19, 1952, at 11:00 p.m., when a crowd of nearly seven hundred students kicked off what would later be dubbed the UVM Lingerie Raid. The participants swarmed throughout the campus invading the female dormitories, trying to steal lingerie. Some sororities participated in the event by defending their undergarments with buckets of ice-cold water, while others willingly gave up their lingerie to the mob. What began as goodhearted fun soon turned into drunken disorder. It was not long before students were climbing and crawling into bedroom windows, stealing the undergarments of unwilling students. Fueled by alcohol, the crowd turned riotous and began damaging property throughout the city. The police and fire departments were called on, but their authority was ignored. The students damaged two police cruisers, and some began throwing rocks and mud at officers. Seeing their appetite for violence, Chief Russell unleashed tear gas and ordered that the fire hoses be opened up on the crowd. At one point, the students became so crazed that Chief Russell nearly called for military reinforcements from Fort Ethan Allen. Students and police officers alike were injured in the mêlée, and many received medical treatment. The *Free Press* described the crowd as being overwhelmed with "a lust for lace."[303]

By 2:00 a.m., the police were able to disperse the students, and several subjects were sent before Judge Joseph C. McNeil. Judge McNeil expressed his disdain for their conduct, especially at a time when their peers were overseas fighting in Korea. Despite his frustration, Judge McNeil showed leniency because he could not find the students entirely responsible for the actions of the mob. As a result, the students were fined thirty-five

Chief Donald P. Russell. *The Burlington Police Department.*

A back alley of Burlington, Vermont, circa 1955. *Special Collections, University of Vermont Libraries.*

dollars and forced to pay court costs for the proceedings.[304] In the days following the riot, Mayor Moran expressed disgust for the students' conduct and frustration at the dismissive response from the university. He also commended the police department for handling a riot that nearly required military intervention.[305]

THE DEATH OF PATROLMAN ROBERT W. PROVOST

On January 13, 1954, the police ambulance was called to Isham Street to transport a sick patient to the hospital. Patrolman Robert W. Provost, one of the newest members of the force, responded to the scene. Assisted by Patrolman Hayes, Provost carried the patient down the stairs and loaded him into the ambulance. With Provost at the wheel, the police ambulance slowly made its way up the hill toward the hospital when suddenly Provost slumped over the steering wheel, unconscious. Officer Hayes quickly gained control of the ambulance and applied the brakes. Patrolman Charles West, who was in a nearby cruiser, responded and rushed Provost to the hospital. Despite the efforts of his fellow officers, Provost died, having suffered a massive heart attack. In death, Provost

Captain Arthur Limoge. *The Burlington Police Department.*

The Burlington Police Department on the steps of city hall, circa 1958. *Special Collections, University of Vermont Libraries.*

Kenneth "Red" Pecor joined the police force in 1947 and attained the rank of captain before retiring in 1978. *The Burlington Police Department.*

left behind his wife and five children.[306] For his service and duty to the department and the city, Provost's name was added to the National Law Enforcement Officers Memorial Wall in Washington, D.C., joining Officers James P. McGrath and J. Albert Fisher.

In 1957, with a population of thirty-seven thousand people, the city had forty-four officers dedicated to its protection.[307] The department was desperate for relief. After a decade of financial neglect, Chief Russell estimated the department to be short a minimum of fifteen officers and pointed out that his men were substantially underpaid. The personnel shortage also limited the number of officers available to attend police training classes because all were needed for the protection of the city.[308]

In 1959, the police department welcomed the city's installation of a one-way traffic system in the business district and also acquired a second Harley Davidson Servi-Car for its fleet in order to help enforce motor vehicle laws within the city, as well as a newly created DWI law.[309]

THE FLYING BANK ROBBER

On February 14, 1959, a notorious criminal came to Chittenden County. His name was Frank Sprenz, but he was most notably referred to as the "Flying Bank Robber."[310] Sprenz became known for committing a series of successful bank robberies but also for his elusive escapes from law enforcement. On two occasions, Sprenz eluded police by stealing airplanes, and his latest robbery yielded $25,935, landing him on the FBI's list of the "Ten Most Wanted Fugitives" on September 10, 1958.[311] Sprenz was also a master of disguise, known to have posed as a college student, a professional football player and a garage mechanic, utilizing a variety of wigs and toupees to alter his appearance.[312] He was said to be a "mechanical genius and a skilled marksman."[313] Sprenz was considered to be extremely dangerous.

On his twenty-ninth birthday, attempting to escape from police, Sprenz steered a stolen single-engine Cessna airplane from Scranton, Pennsylvania, toward the Champlain airport, just north of Burlington. Sprenz landed the airplane on the snow-covered runway and nosed the propeller into a snow bank. From there, he walked to Winooski, where he stole a car and fled the

area.[314] Officer James "Bucky" Scott was one of the many officers who responded to the report of Sprenz's landing. Despite the stalwart efforts of law enforcement, the slippery bandit managed to escape.

On April 15, 1959, Sprenz made his final escape attempt in another stolen airplane, this time heading for Mexico. Authorities were able to track him when the wreckage of the plane was found on the Yucatan island resort of Cozumel, where Sprenz was found posing as a U.S. Highway engineer.[315] For his crimes, Sprenz was sent to the federal penitentiary on Alcatraz Island.[316] Sprenz was given a twenty-five-year sentence, which he would have to serve before facing a number of state charges for lesser offenses.

James "Bucky" Scott, one of the longest-serving members of the department and a legendary figure among its officers. *The Burlington Police Department.*

A TERRIBLE SCANDAL (1960-1969)

In 1961, under the newly elected mayor, Robert K. Bing, the city discovered a concerning disparity in salaries among its various departments. This inequality in pay seemed dependent on whether the employees of the department were working for a revenue-producing department or a non-revenue-producing department, such as the police and fire departments. A salary committee was formed to investigate the inequality but ultimately failed to correct the imbalance.[317] This salary issue, which had gone unaddressed for decades, would combine with human weakness to result in a notorious police scandal that would fracture the century-old foundation of the department.

Since September, Officers John Malloy and John Adams had been reading newspaper articles about a police burglary ring in Denver, Colorado.[318] In Denver, several officers of the department had burglarized stores while on duty and would respond to investigate their crimes.[319] The officers were eventually arrested, and the subsequent investigation revealed that nearly fifty officers had participated in the burglary ring.[320]

It was not long before a rash of unsolved burglaries spread through the downtown district of Burlington. Given the nature of the burglaries and the times they were committed, detectives in the Investigations Bureau, led by Detective Captain Arthur J. Carron, became suspicious and began monitoring the movements of the downtown officers. On December 21, Malloy and Adams were arrested for burglarizing the Above Par Restaurant

on South Winooski Avenue. Additional evidence was found that implicated both men in as many as nine other burglaries in the area. At arraignment, the men pleaded not guilty but later changed their plea. Judge Edward J. Costello weighed the facts of the case and sentenced the men to terms of four to six years at the state prison in Windsor.[321] Unfortunately, the arrest and sentencing of the disgraced officers was only the beginning.

On January 12, 1962, three more police officers were arrested. What was once believed to have been the work of two crooked men was in fact the work of five. Information provided by Malloy and Adams led detectives to the remaining three suspects: Officers Bleau, Bates and Muir.[322] Bates, a veteran officer of the force, was later sentenced to a term of eighteen to thirty-six months in the state prison, while Bleau was sentenced to eight to twenty-four months. Muir was sentenced to a term of six to twenty-four months.

Chief George A. McKenzie served through the difficult days following the Scandal of 1961 and played a key role in the department's survival and restoration. *The Burlington Police Department.*

Due to the recent retirement of Chief Donald Russell, management of the police scandal was passed to the newly appointed chief of police, George McKenzie. Following the arrests of five of his officers, Chief McKenzie contacted the International Association of Chiefs of Police (IACP) and requested that an independent police survey be conducted to assess the department's overall viability and condition.[323] It was his hope that the survey would help improve the department and rebuild the public trust that had been lost. However, public sentiment was not the only thing threatening the police department. McKenzie feared the mass departure of police officers.

On January 15, McKenzie held a special roll call of every member of the department. Amidst an internal investigation that had entered its fourth week, McKenzie addressed the officers. "You've worked hard straight down the line, and I'm damned proud to be your chief. I know what you are getting out on the street," he said, "and I'm proud of how you are reacting to it. Be proud of your uniform. Don't hang your heads."[324]

In the months that followed, the investigation uncovered a striking problem. While no one, including Chief McKenzie, would make excuses for the burglars, the facts and details of the independent survey could not be ignored. The investigation found that most of the stolen items taken by the burglars consisted of basic household items such as food, clothing and baby diapers. Another shocking revelation was that the officers who committed the burglaries were being paid as little as $59.25 per week.[325] The pay was so meager that even Mayor Bing felt compelled to issue a statement; he recommended a 25 percent pay increase for all police officers.[326] In addition, it was discovered that almost all of the officers had to work one or two extra part-time jobs in order to make ends meet.

While the city analyzed the findings of the study, officers were forced to work without days off until more men could be appointed. Low wages, demanding hours and the overall nature of the job were challenges in themselves, but now officers were forced to carry with them the stigma of the scandal on the streets. Many good officers resigned from the department, while those who stayed were haunted by low morale. As the wounded department struggled to retain its officers, Mayor Bing cast another stone. He launched an additional investigation into the past conduct of all police officers, whether or not there was evidence of misconduct.[327]

Chief McKenzie, who had held a steady voice throughout the scandal, responded with ardent disapproval to a second inquiry. He feared that it would deal the department a fatal blow. With his men working extra shifts without overtime pay and being ordered before a political inquisition, McKenzie openly criticized the actions of the mayor.[328] On March 28, 1962, all forty of the remaining members of the force—including Chief McKenzie and Detective Captain Arthur Carron, the man who had arrested the disgraced officers—were interrogated before the board of inquiry. One by one, officers were summoned to the third floor of the police station to swear an oath and answer questions regarding past conduct.[329]

The conclusion of the three-day inquiry resulted in the suspension of one patrolman for unspecified conduct. Upon completion of the inquiry,

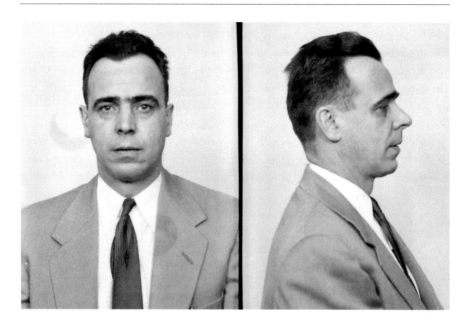

Chief Arthur J. Carron, a veteran of World War II, also served as captain of the Detective Bureau and uncovered the infamous actions of the Scandal of 1961. *The Burlington Police Department.*

Mayor Bing declared his confidence in the remaining members of the police force and professed his hope that the results would dispel further rumors of police misconduct. Whether for the restoration of the public trust or for the exercise of a political engine, the inquiry had taken a toll on the officers of the department. Many who had remained faithful officers felt defeated and weary.

On April 1, 1962, Chief George A. McKenzie resigned as chief of police. McKenzie was a twenty-four-year veteran of the department and had steered it through the difficult days of the scandal. He made no attempt to avoid criticism and took responsibility for his role as an administrator while the burglaries were committed.[330] Recognizing that the department needed to rebuild itself and wanting what was best for the department, McKenzie regretfully submitted his resignation. He left with the full respect of the officers of the department. Arthur J. Carron was selected to be the department's next chief of police.[331] Although he graciously accepted the appointment, Carron remained fully aware of the challenges he would face. He had been handed the helm of a demoralized and undermanned police department, with the expectation of restoring public trust and raising morale.

HISTORIC CRIMES AND JUSTICE IN BURLINGTON, VERMONT

Police K-9 Matt Dillon with his handlers Sergeant Jim Scott, Detective Wayne Liberty and Patrolman John Rouille, 1964. *The Burlington Police Department.*

IN 1963, CHIEF ARTHUR CARRON implemented many of the recommendations made by the International Association of Chiefs of Police (ICAP). A patrol car was added to the fleet, manned by a patrol sergeant, and the radio system was upgraded, resulting in better communications between patrol cars and police headquarters.[332] Carron also implemented a new set of rules and regulations for police officers that was disseminated in the form of a printed manual. It was the first change in police regulations since 1939.[333] He also increased police training for the officers, which included a special firearms training school.[334]

In 1964, while the police commission sought a suitable location for a new police station, the department welcomed the arrival of a police bloodhound, Matt Dillon, named after a character from the western television series *Gunsmoke*. Detective Wayne Liberty, Officer James "Bucky" Scott and Officer John Rouille were assigned the task of training the department's first official K-9.[335]

By 1966, construction had begun on the future police headquarters at 82 South Winooski Avenue, and the department looked forward to a day

The Burlington Police Station at 82 South Winooski Avenue. *The Burlington Police Department.*

when it would have a new police station. It was hoped that the new station would boost morale and help attract new applicants at a time when the city's demand for police services was increasing. In order to accommodate a patrol area expansion, a fourth patrol car was added to the fleet. The year also marked the first time that blue flashing lights and sirens were affixed to Burlington police cruisers.[336]

THE RUDOLPH FAMILY

On January 20, 1967, a horrific event shook the New North End of the city. On that evening, David Rudolph stumbled out of his home at 209 Shore Road and walked to his neighbor's house. When he arrived, the neighbors found him bleeding profusely and immediately called for help. As police and medical personnel arrived, the full extent of the situation was realized.

Officers entered Rudolph's house to find a grisly scene. Mrs. Rudolph was found lying on the kitchen floor, still alive but in critical condition. As they continued into the basement, they found ten-year-old Jacqueline Rudolph lying dead on the floor. She had been severely beaten and was stabbed multiple times in the chest. With the search of the home complete, an eerie revelation came into the minds of the officers. The Rudolphs' sixteen-year-old son, Rodney Rudolph, was nowhere to be found, and the family car was missing. As Mr. and Mrs. Rudolph were rushed to the hospital, police scoured the city looking for their son. Investigators soon learned that Mrs. Rudolph's other son was attending the Weeks School in Vergennes, and they believed that Rodney Rudolph might have gone there to see his brother. They rushed to the school, where they found the Rudolphs' car and Rodney Rudolph. The car was badly damaged, and when investigators interviewed Rudolph, they found that he had a severe cut on his hand. Rudolph was taken into custody and transported back to Burlington.

The Investigative Services Bureau, circa 1972. *From left to right, back row*: Harold Baker, unknown, Charlie Guyette, David Demag, Edwin LaRock and unknown. *Middle row*: Ed Strong, Mike Spernak, Karen Beaulieu, Dennis Godin, Dick Goodrich, Gloria Bancroft, Harold Miles and Kevin Scully. *Front row, seated*: Richard Beaulieu, Priscilla Contois and Wayne Liberty.

An autopsy of Jacqueline Rudolph showed that she had been struck by a blunt object in the head and stabbed twice in the heart. Further investigation revealed that when David Rudolph arrived home on the day of the incident, he began arguing with Rodney about his performance at school. When the argument became heated, Mr. Rudolph exited the house to take out the garbage. Not knowing that Rodney Rudolph had already killed his sister, Mrs. Rudolph began calling to her from the kitchen. At that time, Rodney struck his mother from behind, knocking her to the floor. Armed with a hammer and a large kitchen knife, Rodney proceeded into the garage, where he brutally attacked his stepfather, David Rudolph.

At his arraignment, Rudolph entered a plea of innocent by reason of insanity, and Judge Costello ordered that he be sent to the state hospital for evaluation. After two weeks in the hospital, David Rudolph died from the injuries he had sustained during the attack. After an initial grand jury indicted Rodney Rudolph for the murders of his sister and stepfather, a second grand jury found him to be insane. In light of the conflicting rulings, the murder charges against Rudolph were dropped, and he was sent to the state hospital in Waterbury for treatment. He was released four years later, at the age of twenty-one.[337]

THE BREWER MOTORS SHOOTING

On March 17, 1967, police received information regarding a burglary that was going to take place at the Brewer Motors building on North Avenue. The informant advised that the burglars would be armed with multiple handguns. Acting on the information, police detectives set up inside the building and waited for the burglars to arrive. On March 18, 1967, at 9:30 p.m., the suspects entered the building and attempted to remove a safe from one of the rear offices. When the officers announced their presence, the burglars fled into the automobile showroom. One of the officers fired a warning shot into the air, but the suspects continued to flee farther into the building. Fearing that the burglars were armed, the officers fired at the two men, dropping them to the floor. The men were rushed to the hospital and were later identified as Bruce Delorme and Geary McCuen. Delorme would eventually recover, but on April 11, McCuen died from the gunshot wounds he had sustained during the burglary.

Officers at the shooting range, circa 1975. *The Burlington Police Department.*

An investigation of the scene found blood splatter marking the floor and a shotgun slug embedded in the rear of a 1967 convertible. Although the two suspects were found to be unarmed, a third man escaped and was never identified.[338]

In the days that followed the shooting, newspapers questioned the actions of the police, and citizens responded with an outpouring of support for them. One citizen wrote, "Let's all of us in the city stand up for our policemen against those who wish to be 'outlaws.'"[339] The same citizen continued, "Why not have a bond issue voted upon by the people of our city to pay these men a wage suitable to the dangers they encounter."[340] A more satirical response read, "I suggest that in order to protect the rights of would-be thieves, murderers, rapists, arsonists, etc., we introduce a bill whereby our policemen be stripped of all lethal weapons. Let us arm our patrolmen with water pistols, paper clips, rubber bands and pea shooters."[341] Another citizen outlined a more somber truth: "Supposing it had been the other way around and the officers had been shot? It has happened before. All people say then is, 'Well, it was his job, too bad the poor devil had to get shot!'"[342]

The officers' actions during the shooting received further support from Chief Carron, who stated that any criminal has to assume the consequences of crime, which may include getting shot by the police.[343] State's attorney Patrick J. Leahy agreed with Chief Carron and ruled that the shooting

was justified. With that, the incident took its place in the vast history of the department, but perhaps the most striking fact about the Brewer Motors shooting is that the very building in which the shooting took place, 1 North Avenue, currently houses the Burlington Police Department.

IN 1968, AS THE FIRST group of new officers shipped off to the Randolph Police Training School, the department celebrated its new home at 82 South Winooski Avenue. Under a new roof, the department focused on the increasing problem of narcotics and expanded the number of police detectives assigned to the Investigations Bureau. It also added a fifth patrol

Top: The first police patch worn by officers of the Burlington Police Department. *Author's collection.*

Left: Chittenden County state's attorney Patrick J. Leahy. Leahy would go on to become a ranking senior member of the U.S. Senate. *The Burlington Police Department.*

car to keep pace with the increasing population of the city. However, the department was still seriously understaffed. In 1969, Chief Carron calculated that even if the department added ten additional officers, it would be at a ratio of 1.5 officers per 1,000 citizens, which was well below the national average of 2.1 per 1,000.[344]

MURDER IN THE QUEEN CITY
(1970-1979)

THE RITA CURRAN HOMICIDE

On July 19, 1971, a cold-blooded murder struck at the heart of the city. When officers were called to 17 Brookes Avenue, they found the lifeless body of Rita Curran, a twenty-four-year-old Milton schoolteacher, lying on the floor of her bedroom. Curran had been beaten, strangled and sexually assaulted. The police worked around the clock—interviewing friends, neighbors and family members—as news of the murder spread throughout the city. In the days that followed, police questioned all known sex offenders in the area and sent the evidence collected from the scene to the FBI crime laboratory.[345] Despite their efforts, the identity of Curran's killer remained a mystery. Concern about the homicide was such that local hardware stores reported a 25 percent increase in lock sales.[346] At the same time, police began investigating complaints of a Peeping Tom in the area, thinking that the perpetrator might be linked to the murder.[347] Ultimately, the suspect was never found, and as months turned into years, many people turned their attention to the devil himself: Ted Bundy.

Theodore "Ted" Bundy, the notorious serial killer who plagued Colorado, Florida and California throughout the 1970s, was a native of Burlington, Vermont. Although the murder did not appear to match Bundy's known criminal profile, some wondered if he had killed Rita Curran. After Bundy's arrest and execution, despite the many confessions he made of his murders,

An unspecified crime scene photograph, circa 1970. *From the collection of Richard Rowden.*

investigators were never able to rule out his possible involvement in the Curran murder.

Despite the passing of time, the Burlington Police Department has actively worked the unsolved case for over forty years. It continues to bewitch those who investigate it in the same way that it still haunts the memories of those who lived through the summer of 1971.

The Houdini of Vermont

On May 25, 1973, Wayne Carlson, a fugitive from Canada, was arrested by U.S. Immigration agents and brought to the Burlington Correctional Center. With his arrest, authorities learned of his lengthy criminal record and how he had been the mastermind behind a bank heist in Canada.[348] Despite his reputation, no one was prepared for how resourceful Carlson could be.

Two days later, Carlson received a visit from an acquaintance, Laura Phillips of Burlington. Following a brief conversation in the prison's visitor room, Carlson was escorted back to his cell, where he drew a .38-caliber handgun on six corrections guards. After locking the guards in a holding cell, Carlson walked out the front door of the prison, where a red Opel sedan was waiting for him.

Within hours of the jailbreak, Laura Phillips and two other accomplices were arrested, but Carlson proved to be more elusive and seemingly vanished without a trace. His trail went cold for two days, but on the morning of May 29, the department received a tip that Carlson was hiding in the residence at 25 Sandy Lane. Officers rushed to the house, accompanied by agents from the FBI. With the house surrounded, Detective Harold Miles and Sergeant John King approached the residence as Carlson unknowingly walked outside. Seeing the fugitive, Miles called out to Carlson and warned him that the house was surrounded. In response, Carlson raced back into the house, while Detective Miles and Sergeant King pursued him through the garage and into the kitchen. With officers in pursuit, Carlson hid in one of the bedrooms at the end of a hallway. Aware of the danger they faced, the officers looked down the darkened hallway, knowing that Carlson was in one of the rooms. Detective Miles took a flashlight and rolled it down the hallway, illuminating the unlit room where Carlson was hiding. As Miles peered around the corner, Carlson fired a shot, narrowly missing his target. Miles returned fire and littered the bedroom with shotgun pellets. Convinced of Detective Miles's resolve, Carlson agreed to surrender.

After his arrest, Carlson was sent to the state prison in Windsor to await his trial, but on July 7, 1973, he conducted another daring escape. Accompanied by seven other inmates, Carlson stacked up several picnic tables in the prison yard and climbed over an unguarded wall. He was recaptured on July 9 and was later sentenced to a term of six to ten years.[349] A few weeks later, Carlson completed his fifth escape from prison in ten months and was dubbed the "Houdini of Vermont."[350] Some who failed to recognize Carlson as a violent felon suggested that he be hired by the state as a security consultant for the

The capture of Wayne Carlson by Detective Harold Miles and Sergeant John King. *The Burlington Police Department.*

Correctional Department.[351] In October 1973, the Burlington District Court sentenced Carlson to serve three to seven years for aggravated assault. Upon hearing the verdict, Carlson took two sheriff's deputies hostage and fled from the area in a stolen police cruiser.[352] He led police on a wild manhunt before bloodhounds finally tracked him to a small wooded area in Williston.[353] In addition to sentences for aggravated assault and kidnapping, Carlson was sentenced to a fifteen-year term for his repeated escape attempts.[354] He would split his time between two federal maximum-security prisons, but Carlson was not finished with the State of Vermont. He sued the state, claiming that

 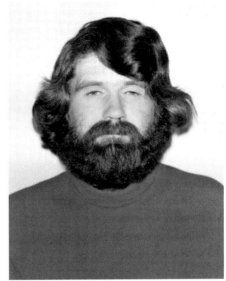

Left: Detective Harold Miles. *The Burlington Police Department*. *Right*: Detective Harold Miles undercover. *The Burlington Police Department*.

his transfer to a federal penitentiary was a violation of his constitutional rights, despite the fact that he had illegally entered the county.[355]

On January 13, 1976, a letter from Carlson, addressed to the people of Vermont, was published in the *Bennington Banner*. In it, Carlson pointed out that since arriving in Vermont, the state had spent nearly $71,441.63 on his incarceration and repeated recaptures. He also requested to be transferred to Canadian authorities to finish out his sentence and reasoned that if he could be transferred to a Canadian prison, then he would no longer be a drain on the state budget.[356] It was the last effort of a cunning international criminal—and it worked.

In February 1976, Governor Salmon pardoned Carlson, with the condition that he not return to Vermont until 1995, when his sentence was scheduled to expire. Carlson was then transferred to Canadian authorities to face charges of attempted murder and bank robbery.[357] Not surprisingly, by March 1976, Carlson had escaped again, having sawed through the bars of the jail.[358] As in the past, Carlson was eventually recaptured and spent most of the next twenty years in prison, finally being paroled in 1999. Over the course of his life, Carlson escaped from prison thirteen times.[359]

HISTORIC CRIMES AND JUSTICE IN BURLINGTON, VERMONT

PAUL LAWRENCE

Chief Arthur Carron was appointed chief of police in the aftermath of the Scandal of 1961. In 1974, his last year as chief, Carron and the department would bear witness to one of the greatest examples of police misconduct in the history of the state. Once again, the officers of the Burlington Police Department would play a key role in correcting a terrible injustice.

Paul Lawrence was a police officer with the Saint Albans Police Department, and in 1974, as part of a joint undercover narcotics initiative, he began working with the Burlington Police Department. In Saint Albans, Lawrence had distinguished himself by making more than one hundred drug arrests and orchestrated one of the biggest drug raids in the state's history. In that case, Lawrence arrested twenty-seven "long-hairs," as he referred to them, on charges relating to heroin, cocaine and LSD.[360] Although many claimed their innocence, Lawrence was getting results in a community that had been overrun by drugs, and his efforts had won the support of local business owners and citizens.[361] After becoming too well known in the Saint Albans area, Lawrence was sent to assist the Burlington Police Department with the drug problem that was plaguing the city.

Lawrence was paired with Detective Kevin Bradley and others from the Burlington Detective Bureau. The arrangement proved difficult for Lawrence, who preferred to work alone. Shortly after his arrival, Detective Bradley became suspicious of Lawrence's tactics and decided to test his new partner. In secret, Bradley asked a cousin of a fellow policeman to pretend to be a drug dealer. Twice, Lawrence claimed to have purchased drugs from the man when he had not. Bradley reported the matter to the state's attorney, Patrick J. Leahy, and set up another test for Lawrence. With the full cooperation of the Burlington Detective Bureau, Bradley brought in an undercover policeman from Brooklyn, New York, Michael F. Schwartz, to work as a decoy in the investigation. A mugshot was taken of Schwartz, and a false police report describing him as a drug dealer was placed in the Burlington police files. Schwartz was given the nickname "The Rabbi."[362]

On July 11, 1974, Sergeant Davis told Lawrence that he had just seen "The Rabbi," a known heroin dealer, sitting in City Hall Park. Meanwhile, Schwartz, acting as "The Rabbi," patiently sat on a bench in City Hall Park, wired with audio-recording equipment. Using a room at the Huntington Hotel, Detectives Bradley and Demag conducted surveillance on Schwartz as he sat in the park. It was not long before they observed Lawrence's blue mustang driving through the area. Lawrence remained parked in the area

Above: Kevin Bradley as both an officer (left) and an undercover drug investigator. Bradley played a major role in the arrest of Paul Lawrence, a corrupt drug investigator who was attached to the Saint Albans Police Department. *The Burlington Police Department.*

Right: Major Donald P. Davis once heroically disarmed a gunman who was threatening an entire neighborhood. He was widely regarded as one of the finest officers in the department. *The Burlington Police Department.*

for thirty minutes but never exited his vehicle. After a few hours, Schwartz left the park and met with Detectives Bradley and Demag. While in the park, Schwartz was not approached by a single person and never had any contact with Paul Lawrence.

Later that day, Lawrence told Detective Bradley that he had purchased two bags of heroin from "The Rabbi" in City Hall Park. The operation was repeated on the following day and yielded similar results. Lawrence was arrested the next day, and a special prosecutor was appointed to investigate

the matter. In the aftermath of his arrest, nearly one hundred cases were dismissed, and those who had been jailed were pardoned. At trial, Lawrence was convicted and sentenced to four to eight years in prison.[363]

Among law enforcement officers, the mention of Lawrence's name stirs feelings of disgust for the man who betrayed his badge. Lawrence's actions left a stain of distrust that would be carried by loyal officers for years, even by those who so honorably worked to bring him to justice. In September 1982, Kevin Bradley was elected state's attorney for Chittenden County and served as such until 1988. He would later accept a position as counsel for the United States Border Patrol in Swanton, and in 1997 he received an appointment a U.S. Immigration judge in Miami, Florida.[364]

ON NOVEMBER 1, 1974, after a long and dedicated career, Chief Arthur J. Carron retired, and Captain Richard Beaulieu was appointed to be Burlington's next chief of police.[365] Beaulieu was quite familiar with the tumultuous nature of policing and became chief at a difficult time. Just two months before his appointment, the department had received harsh criticism for the accidental shooting of a burglary suspect, Luis "Ponce" Rodriguez, and Beaulieu worked hard to boost morale and support his officers during those difficult times. The department also faced a drastic rise in crime. Over the course of 1974, the city would see a 65 percent increase in burglaries, a 138 percent increase in larcenies from motor vehicles and an 800 percent increase in occurrences of counterfeit money—crimes that were believed to be driven by the economic recession.[366]

In 1975, Gloria Bancroft, a policewoman, despite her assignment with the Detective Bureau, was still receiving a policewoman's salary. In the pursuit of equality, Bancroft made her frustrations known and

Patrolman Richard Beaulieu, who would go on to serve as captain of the Detective Bureau and as chief of police. *The Burlington Police Department.*

requested equal pay for equal work, as was required by law. Without an adequate response from the city, Bancroft filed a discrimination lawsuit. In recognition of the salary discrepancy, on October 7, 1975, the department officially recognized Bancroft as the first female detective in the history of the Burlington Police Department.[367]

That same week, the police commission voted to demote Chief Beaulieu, citing "differences in philosophy and policy."[368] In response, Beaulieu stated that he had recently "locked horns" with the commission on several issues and agreed to return to the rank of captain.[369] The police commission appointed Robert Abare to be the next chief of police, but Abare's selection came with a clear stipulation that he could be removed at any time during that year. Abare was instructed to meet daily with Captain Beaulieu and Captain Kenneth "Red" Pecor, who had turned down the job prior to Abare's selection. The police commission also commanded that if the three department heads were not in consensus over any decision, it would be decided by the police commission.[370]

Chief Robert Abare was a graduate of the FBI Academy and served as captain of the Detective Bureau. He also served in the U.S. Army during World War II and in the air force during the Korean War. *The Burlington Police Department.*

Much like Beaulieu, Abare faced many difficult years as chief of police. Nationwide, crimes such as murder, rape and assault and robbery had increased nearly 5 percent over the previous year. Burlington followed those trends with a string of homicides, including the murders of Wendell Emslie, Raymond Michel, Margeret Smith and Judy Dietl, which occurred throughout the years of 1977 and 1978.[371] Abare would serve as chief until 1979, at which time Richard Beaulieu was once again appointed to be chief of police.

The Battery Park Riot

Battery Park has always been a favored attraction for tourists and locals, but by 1979 the park had become a mecca for hundreds of rowdy, beer-drinking youths of the city. Over the summer, incidents of drunkenness and fighting were so prevalent that the park was added to one of the patrol beats. Many longtime residents felt that the park had become unsafe, and in response city officials imposed a midnight curfew in the hope that it might remedy the problem. Instead, it moved the situation closer to its boiling point.

On July 1, 1979, officers with the department arrived in the park to enforce the newly implemented curfew. They were met by 250 people who refused to leave the park and who adamantly disobeyed the repeated orders of police.[372] In response, ten officers arrived in riot gear, while Lieutenant David Demag repeated his orders for the subjects to vacate the park. The crowd began chanting at the officers, and their words soon turned to obscenities. Police commissioner Antonio Pomerleau came on the scene and stoically commented, "This shows we need more cops, not less as the mayor says."[373] It should be noted that a month prior to the incident, Mayor Paquette had hurled a political grenade by threatening to lay off police officers while in the midst of contract negotiations.[374]

The actions of the crowd soon escalated, and a clash became inevitable. The crowd began throwing rocks and beer bottles at the helmeted officers,

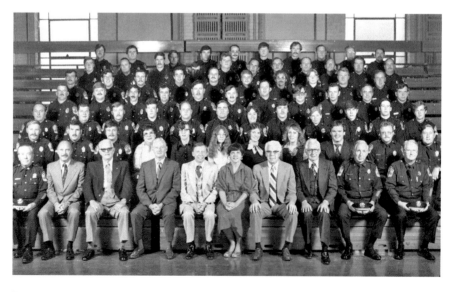

Burlington Police Department, circa 1975. *The Burlington Police Department.*

igniting a riot. The rioters, who initially proclaimed their peaceful intentions, were now brandishing "tire irons, and baseball bats."[375] Police officers began forcing people from the park with batons and fire hoses, and an additional sixty officers were called in to assist with the riot. As the violence continued, police launched smoke bombs and tear gas into the crowd.[376] When the smoke cleared, nine people had been arrested and fifteen police officers were injured. Most had received injuries from hurled rocks and bottles, but some had been struck with bricks. Some of the bottles that were thrown at officers contained a mixture of gasoline and Clorox, causing many to be treated for eye injuries.[377] Those who were arrested had only minor injuries with the exception of one, who claimed that his teeth had been knocked out by a police nightstick.[378] Many city officials who were at the scene praised the department for a job well done in the most dangerous of circumstances. On the following night, another 150 youths gathered in Battery Park and once again clashed with police. The second riot ended with the arrest of three of the group's ringleaders.[379]

The Burlington Police dive team, circa 1974. *Left to right:* John Terrel, unknown, Ed Strong, John Carter, Richard Rowden and Skip Gould. The dive team responded to drownings at North Beach and the Huntington Gorge and operated from the waterfront at Perkins Pier. *From the collection of Richard Rowden.*

In the days that followed, members of the mob accused the police of excessive force and unnecessary violence. One of the protesters stated, "They [the police] were just going like animals. They didn't say anything to us, just ran up and started swinging billy clubs."[380] The same man claimed that he was struck in the back with a club, and several of his relatives were also injured during the riot.[381] In the aftermath, Mayor Paquette came out in support of the police and stated that the situation in Battery Park was a matter of "life and limb."[382] The riot resulted in a ban on cars and motor vehicle traffic in Battery Park, and New England's most scenic view was restored to its former tranquility.

POLITICS, DRUGS AND MASS ARRESTS
(1980-1989)

Throughout the 1980s, the department endured the steady pressures of social change and unrest amidst an increase in crime. It also entered the decade having one of the lowest police salaries in New England. Of the 250 police departments in the Northeast, Burlington officers ranked 230th in salary, with a weekly pay of $194.[383] Regardless of compensation, the officers continued to carry out their duties and face the increasing challenges of the decade.

In 1980, crime in Burlington continued on a violent trend as the city witnessed the public slaying of Bernadette Lesage. It was on a sunny afternoon on the lawn of the Unitarian church that Bernadette Lesage was approached by a stranger. The man, later identified as Louis Hines, proceeded to beat Lesage to death with a lead pipe. The murder highlighted a glaring problem within the framework of the state's mental health policies and the judicial system. In fact, prior to the murder, Hines, who suffered from mental illness, had been released back into society because it was determined that he was not a threat to the public.[384] After the murder, Hines was committed to the Vermont State Hospital for the next twenty-five years. The murder of the Bernadette Lesage was followed by the killings of Linda Dusablon and Ronald Bevins, forming a pattern of violent murders that would consistently reoccur in the years to come.

In February 1985, after the retirement of Chief Beaulieu, the police commission selected William Burke to be the next chief of police. Burke's abilities as a police officer were unquestioned, as he was a former commander

HISTORIC CRIMES AND JUSTICE IN BURLINGTON, VERMONT

The Investigative Services Bureau, circa 1982. *From left to right, back row*: Jeff Payne, Dick Hebert, Edwin LaRock and Miner Tuttle. *Middle row*: Emmet Helrich, Mike Spernak, David Demag, unknown, Theresa Greenough, Dick Goodrich, Butch Burns and Richard Rowden. *Front row, seated*: Wayne Liberty, Kevin Scully and Chief Richard Beaulieu. *The Burlington Police Department.*

with the Los Angeles Police Department. Selected from outside the ranks of the department, Burke did little to hide his feelings about what was best for it. He was also very outspoken when it came to law enforcement and the criminal justice system. He criticized judges for being "overly concerning with protecting the rights of a criminal" and believed that prisoners should be made to work to pay for their stay in jail.[385] Burke even advocated for the return of the death penalty for murderers. It was Burke's hardline stance on modern issues that drew the attention of Mayor Bernie Sanders.

The event that first rocked the political ship was the Federal Building protest in 1985. In May, approximately one hundred people came to the Federal Building to protest the trade embargo levied against Nicaragua by the Reagan administration. Most acted within their rights, but several in the group began blocking the entrance to the building. In all, eleven protesters were arrested for disorderly conduct.[386] When it was discovered that an undercover policeman had been in the crowd, the protesters became enraged. Criticism was leveled against Chief Burke, who authorized

the undercover surveillance. Many claimed that it was "an unwarranted invasion of the privacy of the demonstrators" and accused the police department of intimidation.[387] A single undercover policeman had intimidated a crowd of nearly one hundred protesters who had gathered in public in front of a government building. To throw fuel on the fire, Mayor Sanders came out in support of the demonstrators.[388]

By June of that year, the police department and the mayor's office seemed pitted against each other. Demonstrations at the Federal Building continued throughout the summer, and the situation worsened when police arrested two demonstrators, later discovering that the arrestees were city officials employed in the mayor's office. Chief Burke indicated that if the city officials felt "so strongly about American policies in Central America than they should go there."[389]

While city hall and the demonstrators were concerned with police surveillance at political demonstrations, the Old North End of the city was becoming overrun with drugs. By 1985, crack cocaine was prevalent, and Burlington had developed a large appetite for narcotics, attracting drug dealers from the larger cities of New England. In fact, statistics showed a 239 percent increase in the number of drug investigations over the previous year.[390]

On January 29, 1986, Chief William Burke announced his resignation. In light of the opposition he faced from city hall, his decision came as no surprise. However, the manner in which he left is worth noting. Burke secretly announced his resignation to the police commission, which immediately selected Kevin P. Scully as his replacement, removing any opportunity for Mayor Sanders to oppose the decision. In fact, Mayor Sanders learned of Burke's resignation and Scully's appointment from a news reporter.[391]

Chief Kevin P. Scully. *The Burlington Police Department.*

Police commissioner Antonio Pommerleau. *The Burlington Police Department.*

Kevin Scully was a tested veteran of the department who came from unorthodox beginnings. Born into a devout Catholic family, Scully once considered becoming a priest and also worked as an embalmer. In his police career, he had worked through the ranks to become commander of the Detective Bureau before being appointed chief of police.

In the following year, the department experienced a series of difficult departures. The first came on Friday, July 24, 1987, in the death of a former chief of police Donald Russell.[392] The second departure, although far less grave, was uniquely felt. In September, after serving on the police commission for seventeen years, Antonio Pomerleau resigned. In his tenure, the self-made millionaire and philanthropist had developed a critical understanding of city politics and had remained entirely dedicated to the improvement of the police department.[393] His time as police commissioner had come to an end, but the Pomerleau legacy and his continued support for the police department has carried on into the present years.

In January 1988, Congress made heavy cuts to law enforcement funding, but that was only part of the problem.[394] Police departments, including Burlington, were dreadfully understaffed. A study found that law enforcement agencies were in a losing battle with officer turnover. Chief Scully commented on the issue and pointed out that Burlington officers "do in a 24-hour period what other departments do in a week." Scully continued, "You have to be a very skilled individual in order to keep your head above the waterline here."[395] With the increasing demands being placed on the department, the problems of recruitment and retention of officers would continue to plague the profession.

It was also during this time that one of the most controversial social issues of the century was playing out on a local stage. Throughout the late 1980s, a group of anti-abortionists routinely engaged in acts of civil disobedience

HISTORIC CRIMES AND JUSTICE IN BURLINGTON, VERMONT

Mayor Bernie Sanders, McGruff the Crime Dog and Chief Kevin Scully. *The Burlington Police Department.*

by physically blocking the entryways to two abortion clinics in the city. The demonstrations conducted at the Planned Parenthood abortion clinic on Mansfield Avenue and the Vermont Women's Health Center on North Avenue often led to mass arrests, which imposed a significant burden on the resources of the department. As time went on, the protesters began using advanced locking systems and resistance techniques in order to make their removal from the clinics more difficult. In some instances, the bike locks they used could not be removed, and protesters were sent to prison still bound in their restraints.[396] As a result, Kryptonite bike locks became a symbol for the protester movement. A relic of these mass arrests was a collection of defeated bike locks that the department had acquired in connection with the anti-abortion protests. The pile of locks represented approximately 550 related arrests.[397] Eventually, the group discontinued the practice of blockading clinics and disbanded. However, the issue of abortion remains controversial in the city, as peaceful prayer vigils at abortion clinics continue to this day.

RECENT DECADES (1990-2015)

By 1990, the condition of the police station at 82 South Winooski Avenue was unsuitable, and it was clear that something had to be done. For years, officers had dealt with a leaking roof, dilapidated ceilings and a series of holes in the walls due to its unruly clients. In addition to its poor condition was the fact that the building was never designed to be a police station. In fact, there were no holding cells. To complete the picture, there were exposed electrical wires protruding from the ceiling, and the dispatchers were housed in the basement as if in solitary confinement. In 1990, a plan was formulated for a massive renovation to the existing building at an estimated cost of $5.3 million. In November of that year, Burlington voters rejected the proposed renovations in favor of a waterfront development project.[398]

In 1992, while the nation was horrified by the beating of Rodney King, local voices were calling for increased police protection. The call came after a series of violent acts that included the arson of the Steer & Stein Restaurant, the stabbing death of Kelly Baer and a drug-related shooting on Elmwood Avenue that killed one woman and two men.[399] The crime problem in the Old North End was so great that many residents considered moving, but due to financial limitations, many had nowhere else to go. The crime wave struck while politicians where trying to increase housing in the city and develop the waterfront at the expense of key pieces of infrastructure, such as the police department. Some believed that city politicians were pursuing big city development and growth while ignoring the problems associated with such endeavors.[400]

To complicate matters, by 1993, it was clear that heroin had infiltrated the Green Mountain State. By driving just a few hours from Boston and New York, drug dealers could triple their profits, buying cheap in the city and selling it high in Burlington. Some argued that methadone treatment facilities would help solve the problem, despite counter arguments that the clinics would only fuel addiction.[401] The clinics would eventually come to Vermont, and regardless of their performance, in 2014 heroin use had become so rampant that it was viewed as a statewide emergency.

On November 3, 1993, the department mourned the loss of the man who had overseen its resurrection: Chief Arthur Carron.[402] In the same spirit of resurrection, in April 1994, Antonio Pomerleau announced that he would take the matter of a new police station into his own hands. He purchased the Acme Paint and Glass building, located at 1 North Avenue, with the sole intention of transforming it into police headquarters.[403] Pomerleau renovated the property and sold it to the city for no profit. Pomerleau's capacity for charitable giving had been well established, but this latest act was both generous and symbolic. The building had been the scene of the Brewers Motors shooting and had served as a backdrop for the Battery Park Riot in 1979.

In May 1998, Chief Scully quietly announced his retirement. As chief, Scully had instituted a return to assigned patrol beats while at the same time implementing a community-based policing approach to combating crime in the city. In a gesture indicative of his character, Scully did not make a public announcement, as he did not wish to distract from the service of other retiring officers.[404]

In December 1998, for the first time in the department's long history, a woman was appointed chief of police. Alana Ennis, the former chief of the Duke University Police Department, was selected for the department's top office. Ennis began her law enforcement career in 1975 and later worked for the city of Durham, North Carolina, as the director of public safety.[405] Her arrival was welcomed at a time when more and more women were entering the male-dominated profession.

Ennis came to Burlington during a time of heightened concern around underage drinking and quality of life issues. She worked to address the problems while maintaining an awareness of the limitations of the department. Ennis quickly acquired new equipment for her officers; this included new police cruisers and semi-automatic pistols. She reinstated the rank of sergeant and took a realistic approach to drugs and alcohol, assertively canceling the DARE program, which had proven to be ineffective. Her

Corporal Thomas Radford with K-9 Stoney (2000–08). In 2008, Radford and Stoney were inducted into the Vermont K-9 Hall of Fame and set a record with 1,010 drug finds. *The Burlington Police Department.*

decisiveness was jarring to some, and as with all chiefs of police, she was not without critics.[406] The fact remained that during her tenure the department improved greatly and received an International Association of Chiefs of Police (IACP) Community Policing Award and a Metlife Community-Police Partnership Award in 2001. In that same year, she personally received an IACP Civil Rights Award and the YWCA Susan B. Anthony Trailblazer

Corporal Wade Lebrecque with K-9 Andre (2007–present). *The Burlington Police Department.*

award. Ennis remained at the helm of the department for five years and saw it through the difficulties of 9/11 before departing in 2003.

In October 2003, Mayor Clavelle announced that Thomas R. Tremblay would be the department's next chief of police.[407] Under his term, the department would investigate the diabolical murders of two of Burlington's innocents, Laura Winterbottom and Michelle Gardner-Quinn. In addition to the criminal happenings of the city, the department worked to improve victim services and its community-based approach to policing. As in the past, the department was hampered with the challenges of recruiting qualified applicants

Corporal Trent Martin with K-9 Capone (2000–present). *The Burlington Police Department.*

and retaining veteran officers. It was also during this time that several officers of the department were called on for their honorable commitments to the National Guard, serving in Bosnia, Afghanistan and Iraq.[408]

By 2006, the department's resources were highly focused on street-level drug activity and maintaining quality of life issues in the neighborhoods surrounding the college campuses. In that year, the department kept pace with previous years, answering approximately forty thousand calls for service, resulting in over 3,400 arrests.[409] In 2007, the department embraced the latest advancement in police technology and implemented the use of electronic control devices (Tasers).[410] This step marked the first of many into

a new era of police technology, accompanied by the appointment of Chief Michael Schirling in 2008.

In the most recent years, the department has implemented an online-based crime reporting system, a crime-data mapping system, Internet-based information sharing with the public and an advanced web-based computer system that merged the functions of police communications and record management.[111] This new system was enhanced by the utilization of portable electronic devices by officers of the department. In keeping with this technological trend, the department also embraced the use of portable video-recording devices worn by officers on patrol.[112] These advancements in technology, as well as a training program that now includes topics relating to bias-free policing, mental illness, domestic violence and use of force, have combined to place the Burlington Police Department at the forefront of modern policing.

As the department looks toward the future, it remains focused on its responsibilities. Often overshadowed by the latest news of police-related incidents is the department's most fundamental commitment to the safety of its citizens, the preservation of peace and the pursuit of justice. The offering of public trust and support by the citizenry combined with the dedication and sacrifices made by members of the police department have culminated in a 150-year-old tradition. It has been a shared commitment and a human endeavor worthy of praise and admiration.

NOTES

The Early History of Law Enforcement in Burlington, Vermont

1. Charles E. Allen, *About Burlington, Vermont* (Burlington, VT: H.J. Shanley & Co., 1905), 6–7.
2. Ibid.
3. Nathan Hoskins, *A History of the State of Vermont: From Its Discovery and Settlement to the Close of the Year MDCCCXXX* (Vergennes, VT: J. Shedd, 1831), 293–95.
4. Ibid.
5. Edward Conant, *The Geography, History, Constitution and Civil Government of Vermont: Published Expressly to Comply with the State Laws* (n.p.: Tuttle Company, 1896), 233.
6. John J. Duffy, Samuel B. Hand and Ralph H. Orth, *The Vermont Encyclopedia* (n.p.: University Press of New England, 2003), 177.
7. Hamilton Child, *Gazetteer and Business Directory of Chittenden County, Vermont for 1882–1883* (Cambridge, MA: Harvard University, printed from the Journal Office, 1882).
8. William S. Rand, *History of Chittenden County, Vermont: With Illustrations and Biographical Sketches of Some of Its Prominent Men and Pioneers* (Syracuse, NY: D. Mason & Co., 1886), 401.
9. Sewall S. Cutting, *Burlington, Vt. as a Manufacturing, Business, and Commercial Center: With Brief Sketches of Its History, Attractions, Leading Industries, and Institutions* (Glen Falls, NY: C.H. Possons, 1889), 15–16.

10. Abby Marie Hemenway, *The Vermont Historical Gazetteer: A Magazine, Embracing a History of Each Town, Civil, Ecclesiastical, Biographical and Military* (1867).
11. *Burlington Free Press*, October 26, 1838.
12. Ibid.
13. Cutting, *Burlington, Vt.*
14. Suzanne King and Peter Shoemaker, "Public History Practicum: A Look at the History of the Burlington, Vt. Police Department," *University of Vermont Historical Review* 3, no. 2 (1990): 13–31.
15. Ibid.
16. Ibid.
17. Ibid.
18. Edward T. Howe, "Vermont Incorporated Villages: A Vanishing Institution," *Vermont History* 72 (2005): 31.
19. Allen, *About Burlington.*

An Unruly Place (1865–1869)

20. *Report of the Selectman and Other Officers of the Town of Burlington* (Burlington, VT: Times Book and Job Steam Printing, 1865).
21. *Burlington Free Press Weekly*, March 10, 1910, 5.
22. Robert C. Wadman and Thomas Allison William, *To Protect and to Serve: A History of Police in America* (Upper Saddle River, NJ: Pearson Prentiss Hall, 2004), 63–64.
23. Robert J. Resnick, *Legendary Locals of Burlington, Vermont* (Charleston, SC: Arcadia Publishing, 2013), 10.
24. Hiram Carleton, *Genealogical and Family History of the State of Vermont: A Record of the Achievements of Her People in the Making of a Commonwealth and Founding of a Nation*, vol. 1 (New York: Lewis Publishing Co., 1903).
25. *Burlington Weekly Free Press*, February 23, 1905, 8.
26. *Report of the Selectman*, 1865.
27. King and Shoemaker, "Public History Practicum."
28. *The Charter and Ordinances with the Address of Hon. A.L. Catlin, Mayor, June 7, 1865, and Annual Report of Officers and Committees of the City of Burlington for the Financial Year Ending Feb. 1st, 1866* (Burlington, VT: Free Press Steam Job Printing Office, 1866).
29. *Report of the Selectman*, 1865.
30. *Charter and Ordinances*, 1866.

31. *Burlington Weekly Free Press*, April 13, 1888.
32. Ibid., April 13, 1866.
33. Ibid.
34. Ibid., April 13, 1888.
35. Ibid., April 20, 1866.
36. Ibid., April 13, 1866.
37. Ibid.
38. Ibid.
39. Ibid.
40. Ibid., March 27, 1868.
41. Ibid.
42. Carleton, *Genealogical and Family History.*
43. *Address of Hon. T.E. Wales, Mayor, April 2, 1866, and Annual Report of the Officers of the City of Burlington for the Financial Year Ending February 1, 1867* (Burlington, VT: Times Steam Book and Job Printing Office, 1867).
44. *Annual Reports of the Officers of the City of Burlington, Vt. for the Financial Year ending February 1, 1868* (Burlington, VT: Free Press Steam Book and Job Printing House, 1868).
45. Ibid.
46. King and Shoemaker, "Public History Practicum."
47. *Fourth Annual Report of the City Government of the City of Burlington, Vt., 1868–69* (Burlington, VT: R.S. Styles, Steam Book and Job Printer, 1869).

A Difficult Beginning (1870-1879)

48. *Sixth Annual Report of the City Government of the City of Burlington, Vt., for the Municipal Year Ending January 31, 1871* (Burlington, VT: Free Press Steam Job Printing House, 1871).
49. Ibid.
50. *Eighth Annual Report of the City of Burlington, Vermont, with the Amended Charter, and Ordinances in Force February 1, 1873* (Burlington, VT: R.S. Styles, Steam Book and Job Printer, 1873).
51. *Ninth Annual Report of the City of Burlington, Vermont* (Burlington, VT: Free Press Print, 1874).
52. *Tenth Annual Report of the City Government of the City of Burlington, Vt., for the Municipal Year Ending December 31, 1874* (Burlington, VT: R.S. Styles, Steam Job Printing House, 1875).

53. *Twelfth Annual Report of the City of Burlington, Vermont, for the Municipal Year Ending December 31, 1876* (Burlington, VT: R.S. Styles, Steam Job Printing House, 1877).
54. Ibid.
55. Ibid.
56. *Thirteenth Annual Report of the City Government of Burlington, Vermont, for the Municipal Year Ending December 31, 1877* (Burlington, VT: R.S. Styles, Steam Job Printing House, 1878).
57. *Fifteenth Annual Report of the City of Burlington, Vermont for the Year Ending Dec. 31, 1879* (Burlington, VT: Free Press Association, 1880).
58. Ibid.

Farewell to the Chief (1880-1889)

59. *Seventeenth Annual Report of the City of Burlington, Vermont for the Year Ending December 31, 1881* (Burlington, VT: Free Press Association, 1882).
60. Carleton, *Genealogical and Family History*.
61. *Burlington Weekly Free Press*, December 22, 1882, 5.
62. *Nineteenth Annual Report of the City of Burlington, Vermont for the Year Ending December 31, 1883* (Burlington, VT: Free Press Association, 1884).
63. *Burlington Weekly Free Press*, January 4, 1926.
64. Ibid., September 25, 1885.
65. Ibid., January 4, 1926.
66. *Vermont Watchman*, January 23, 1895.
67. *New York Times*, August 4, 1894, 3.
68. Vermont Supreme Court, *Reports of Cases Argued and Determined in the Supreme Court of the State of Vermont: Reported by the Judges of Said Court, Agreeably to a Statute Law of the State*, vol. 67 (1895).
69. Prentiss Cutler Dodge, *Encyclopedia, Vermont Biography: A Series of Authentic Biographical Sketches of the Representative Men of Vermont and Sons of Vermont in Other States* (n.p.: Ullery Publishing Company, 1912).
70. William Wirt Henry (1831–1915) Family Papers, 1846–1915, Doc 527-528, Size B, C & D, Vermont Historical Society, Barre, VT.
71. *Burlington Weekly Free Press*, January 4, 1926.
72. *Twenty-fifth Annual Report of the City of Burlington, Vermont for the Year Ending December 31, 1889* (Burlington, VT: R.S. Styles, Book and Job Printers, 1890).
73. *Thirty-third Annual Report of the City of Burlington, Vermont for the Year Ending December 31, 1897* (Burlington, VT: R.S. Styles, Book and Job Printers, 1898).

The Pickpocket, a Serial Killer and the Mad Riot (1890–1899)

74. *Twenty-sixth Annual Report of the City of Burlington, Vermont for the Year Ending December 31, 1890* (Burlington, VT: Free Press Association, 1891).
75. Carleton, *Genealogical and Family History*.
76. *Twenty-eighth Annual Report of the City of Burlington, Vermont for the Year Ending December 31, 1892* (Burlington, VT: Free Press Association, Printers and Binders, 1893).
77. Federal Writer's Project, *Vermont: A Guide to the Green Mountain State* (Washington, D.C.: U.S. History Publishers, 1937).
78. Ibid.
79. *Bennington (VT) Banner*, August 3, 1894.
80. *Vermont Phoenix*, August 17, 1894.
81. Thomas Byrnes, *Professional Criminals of America* (n.p.: Cassell Limited, 1886).
82. *Vermont Phoenix*, August 17, 1894, 3.
83. Ibid.
84. *Vermont Watchman*, August 1, 1894, 8.
85. *Daily News-Democrat*, December 27, 1902.
86. *Vermont Phoenix*, August 17, 1894.
87. *Thirty-first Annual Report of the City of Burlington, Vermont for the Year Ending December 31, 1895* (Burlington, VT: R.S. Styles, Book and Job Printers, 1896).
88. *Burlington Weekly Free Press*, July 4, 1895, 3.
89. Ibid., July 18, 1895, 2.
90. David J. Blow, *Historic Guide to Burlington Neighborhoods*, vol. 3 (Burlington, VT: Chittenden County Historical Society, 2003).
91. *New York Times*, October 31, 1895, 13.
92. *Burlington Weekly Free Press*, July 18, 1895, 2.
93. *New York Times*, October 29, 1895, 13.
94. Ibid.
95. Blow, *Historic Guide to Burlington*.
96. Wilbur R. Miller, *The Social History of Crime and Punishment in America: A-De*, vol. 1 (n.p.: SAGE publishers, 2012).
97. Ibid.
98. Ibid.
99. Ibid.
100. Blow, *Historic Guide to Burlington*.
101. *Vermont Phoenix*, March 12, 1897, 3.
102. *Thirty-third Annual Report*, 1898.

103. Ibid.
104. Vermont Public Documents, 1880.
105. *Burlington Weekly Free Press*, January 26, 1899.
106. Ibid.
107. Ibid., July 7, 1898.
108. Ibid.
109. Ibid., September 8, 1898, 8.
110. Ibid.
111. Ibid.
112. Ibid.
113. Ibid.
114. Ibid.
115. Ibid.
116. Ibid.
117. Ibid.
118. Ibid.
119. Ibid., September 15, 1898, 8.
120. Ibid., September 8, 1898.
121. Ibid., January 26, 1899.
122. Ibid., December 14, 1899, 2.
123. Ibid.
124. Ibid., December 21, 1899.
125. Ibid., January 9, 1902.

The Death of a Policeman (1900-1909)

126. *Thirty-seventh Annual Report of the City of Burlington, Vermont for the Year Ending December 31, 1901* (Burlington, VT: Free Press Association, Printers, Binders, and Stationers, 1902).
127. Scott Wheeler, *Rumrunners & Revenuers: Prohibition in Vermont* (Shelburne, VT: New England Press, Inc., 2002).
128. *Thirty-ninth Annual Report of the City of Burlington, Vermont for the Year Ending December 31, 1903* (Burlington, VT: Free Press Association, Printers, Binders, Stationers, 1904).
129. Marilyn Corsianos, *The Complexities of Police Corruption: Gender, Identity, and Misconduct* (n.p.: Rowman and Littlefield Publishers, 2012), 3–5.
130. *Vermont Phoenix*, May 1, 1903, 3.
131. Duffy, Hand and Orth, *Vermont Encyclopedia*.

132. Michael Sherman, Gene Sessions and P. Jeffrey Potash, *Freedom and Unity* (Barre: Vermont Historical Society, 2004).
133. *Vermont Watchman*, June 11, 1903.
134. *Burlington Weekly Free Press*, August 20, 1903.
135. Ibid., August 13, 1903.
136. Ibid., August 20, 1903.
137. *Bennington (VT) Banner*, February 12, 1904, 4.
138. *Burlington Weekly Free Press*, May 19, 1904, 13.
139. Ibid.
140. Ibid.
141. Ibid.
142. Ibid.
143. Ibid.
144. Ibid.
145. Ibid.
146. Ibid., September 28, 1905.
147. Ibid.
148. Ibid.
149. Ibid., October 12, 1905.
150. Ibid., January 10, 1907, 6.
151. *Rules and Regulations for the Government of the Police Department of the City of Burlington, Vt., 1907* (Burlington, VT: Free Press Printing Co., 1907).
152. *Burlington Weekly Free Press*, March 4, 1909.
153. *Vermont Watchman*, November 11, 1909, 4.
154. Ibid.
155. Ibid.
156. Ibid., January 13, 1910, 5.

A Woman in the Ranks (1910–1919)

157. *Forty-sixth Annual Report of the City of Burlington, Vermont for the Year Ending December 31, 1910* (Burlington, VT: Free Press Printing Co., 1911).
158. *Burlington Weekly Free Press*, May 25, 1911.
159. Ibid.
160. Ibid.
161. Ibid., June 22, 1911.
162. Ibid.
163. Ibid.

164. Ibid.
165. Ibid., March 14, 1912.
166. Ibid., March 21, 1912.
167. Ibid., October 16, 1913.
168. *Forty-ninth Annual Report of the City of Burlington, Vermont for the Year Ending December 31, 1913* (Burlington, VT: Free Press Printing Co., 1914).
169. *Fiftieth Annual Report of the City of Burlington, Vermont for the Year Ending December 31, 1914* (Burlington, VT: Free Press Printing Co., 1915).
170. *Burlington Weekly Free Press*, June 4, 1914.
171. Ibid., July 9, 1914
172. Ibid., July 10, 1913.
173. Ibid., March 4, 1915, 7.
174. *Fifty-third Annual Report of the City of Burlington, Vermont for the Year Ending December 31, 1917* (Burlington, VT: Free Press Printing Co., 1918).
175. *Fifty-fourth Annual Report of the City of Burlington, Vermont for the Year Ending December 31, 1918* (Burlington, VT: Free Press Printing Co., 1919).
176. *Burlington Weekly Free Press*, August 23, 1917.
177. King and Shoemaker, "Public History Practicum," 13–31.
178. *Fifty-fifth Annual Report of the City of Burlington, Vermont for the Year Ending December 31, 1919* (Burlington, VT: Free Press Printing Co., 1920).
179. King and Shoemaker, "Public History Practicum," 13–31.
180. *Burlington Weekly Free Press*, May 16, 1918, 9.
181. Ibid.
182. Ibid.
183. Dennis Nishi, *Prohibition* (n.p.: Greenhaven Press, 2004).
184. *Fifty-fifth Annual Report*, 1920.
185. Ibid.
186. *Burlington Weekly Free Press*, January 1, 1920, 11.
187. Ibid.
188. Ibid.
189. Ibid., October 23, 1919.
190. Ibid.
191. Ibid.

A Tumultuous Decade (1920-1929)

192. *Fifty-sixth Annual Report of the City of Burlington, Vermont for the Year Ending December 31, 1920* (Burlington, VT: Free Press Printing Co., 1921).

193. *Burlington Weekly Free Press*, January 8, 1920.
194. Ibid., September 30, 1920.
195. Ibid.
196. *Fifty-eighth Annual Report for the City of Burlington, Vermont for the Year Ending December 31, 1922* (Burlington, VT: Free Press Printing Co. 1923).
197. *Fifty-ninth Annual Report for the City of Burlington, Vermont for the Year Ending December 31, 1923* (Burlington, VT: Free Press Printing Co., 1924).
198. *Burlington Weekly Free Press*, December 2, 1922.
199. Ibid.
200. Ibid.
201. Ibid.
202. Ibid.
203. Ibid., December 4, 1922.
204. Ibid.
205. Ibid.
206. Ibid., September 4, 1922.
207. Ibid., June 11, 1923.
208. Ibid.
209. Ibid.
210. Ibid.
211. Ibid., August 11, 1924.
212. Ibid.
213. Ibid., August 14, 1924.
214. Ibid.
215. Ibid.
216. Ibid., August 15, 1924.
217. *New York Evening Post*, September 3, 1925.
218. *Burlington Weekly Free Press*, December 3, 1925.
219. *One Hundred and Sixth Annual Report, City of Burlington, Vermont, 1971, for the Year Ended June 30, 1971* (Burlington, VT: Free Press Printing Co., 1972).
220. *Burlington Weekly Free Press*, September 25, 1925.
221. Doris Weatherford, *Women in American Politics: History and Milestones*, vol. 1 (n.p.: SAGE, 2012).
222. *Burlington Weekly Free Press*, January 4, 1926.
223. Ibid.
224. Ibid., January 8, 1926.
225. Ibid.
226. Ibid., March 26, 1926.
227. Ibid., March 3, 1926.

228. Ibid.
229. Ibid.
230. Ibid., November 9, 1927.
231. Deborah P. Clifford and Nicholas R. Clifford, *"The Troubled Roar of the Waters": Vermont in the Flood and Recovery, 1927–1931* (n.p.: University Press of New England, 2007), 6.
232. *Sixty-fourth Annual Report of the City of Burlington, Vermont for the Year Ending December 31, 1928* (Burlington, VT: The Lane Press Inc., 1929).
233. *Sixty-fifth Annual Report of the City of Burlington, Vermont, for the Year Ended December 31, 1929* (Burlington, VT: Free Press Printing Co., 1930).

At Odds with City Hall (1930–1939)

234. *Burlington Weekly Free Press*, September 1, 1930.
235. *Sixty-seventh Annual Report of the City of Burlington, Vermont, for the Year ended December 31, 1931* (Burlington, VT: Lane Press Inc., 1932).
236. *Burlington Weekly Free Press*, January 1, 1932.
237. Ibid., July 30, 1931.
238. Ibid.
239. *Sixty-seventh Annual Report.*
240. *Burlington Weekly Free Press*, September 22, 1934.
241. Ibid., April 27, 1933.
242. Ibid., March 26, 1934.
243. Ibid., May 10, 1934.
244. Ibid.
245. Ibid.
246. Ibid., May 15, 1934.
247. Ibid.
248. Ibid.
249. *Seventy-first Annual Report of the City of Burlington, Vermont for the Year and One-half ended June 30, 1936* (Burlington, VT: Free Press Printing Co., 1937).
250. *Burlington Weekly Free Press*, September 20, 1935.
251. Ibid., February 5, 1936.
252. Ibid., May 8, 1936.
253. Ibid., October 24, 1936.
254. Ibid., May 15, 1936.
255. *Seventy-second Annual Report of the City of Burlington, Vermont for the Year Ending June 30, 1937* (Burlington, VT: Free Press Printing Co., 1938).

256. *Burlington Weekly Free Press*, November 1, 1937.
257. *Seventy-third Annual Report of the City of Burlington, Vermont for the Year Ending June 30, 1938* (Burlington, VT: Free Press Printing Co., 1939).
258. *Burlington Weekly Free Press*, August 4, 1938.
259. Ibid., August 15, 1938.
260. Ibid., May 16, 1939.
261. *Seventy-fourth Annual Report of the City of Burlington, Vermont for the Year Ending June 30, 1939* (Burlington, VT: Free Press Printing Co., 1940).
262. *Burlington Weekly Free Press*, October 24, 1938.
263. Ibid., March 15, 1939.
264. Ibid., March 22, 1939.
265. Ibid., April 11, 1939.
266. *Seventy-fourth Annual Report*, 1940.
267. *Burlington Weekly Free Press*, May 5, 1939.
268. Ibid., July 19, 1939.
269. Ibid.
270. Ibid.
271. Ibid.
272. Ibid.
273. Ibid., October 11, 1939.
274. Ibid., July 21, 1939.
275. Ibid.
276. Ibid.
277. Ibid., July 25, 1939.
278. Ibid., July 22, 1939.

While the World Was at War (1940-1949)

279. *Seventy-fifth Annual Report of the City of Burlington, Vermont, for the Year Ending June 30, 1940* (Burlington, VT: Free Press Printing Co., 1941).
280. Ibid.
281. *Anniston (AL) Star*, October 2, 1941, 8.
282. *Burlington Weekly Free Press*, November 11, 1940.
283. Ibid., November 25, 1940.
284. *Seventy-sixth Annual Report of the City of Burlington, Vermont, for the Year Ending June 30, 1941* (Burlington, VT: Free Press Printing Co., 1942).
285. *Burlington Weekly Free Press*, January 22, 1942.

286. *Seventy-eighth Report of the City of Burlington, Vermont, for the Year Ending June 30, 1943* (Burlington, VT: Free Press Printing Co., 1944).
287. Ibid.
288. *Burlington Weekly Free Press*, April 24, 1943.
289. Ibid., December 29, 1943.
290. Ibid., April 3, 1944.
291. Ibid., July 9, 1945.
292. Ibid., December 16, 1947.
293. Ibid., March 12, 1948.
294. Ibid., March 13, 1948.
295. Ibid., March 16, 1948.
296. *Lewiston (ME) Daily Sun*, August 31, 1950, 1.
297. *Spartanburg (SC) Herald-Journal*, August 3, 1952.
298. *Schenectady (NY) Gazette*, February 9, 1954.
299. *Lewiston (ME) Daily Sun*, December 8, 1954, 19.

THE FIRE AND A FLYING BANK ROBBER (1950-1959)

300. Jack R. Greene, *The Encyclopedia of Police Science*, vol. 1 (n.p.: Taylor & Francis, 2007).
301. *The Vermonter: The State Magazine*, vols. 16–19 (1911).
302. *Burlington Weekly Free Press*, May 25, 1951, 15–28.
303. Ibid., May 21, 1952, 11–18.
304. Ibid., May 28, 1952.
305. Ibid., May 21, 1952.
306. Ibid., January 14, 1954.
307. *Ninety-third Annual Report of the City of Burlington, Vermont* (Burlington, VT: Free Press Printing Co., 1959).
308. *Burlington Weekly Free Press*, November 13, 1957.
309. *Ninety-fourth Annual Report City of Burlington for the Year Ending June 30, 1959* (Burlington, VT: Free Press Printing Co., 1960).
310. Jerry Lewis Champion Jr., *Alcatraz Unchained* (n.p.: AuthorHouse, 2012).
311. Ibid.
312. *(Florence, AL) Times Daily*, May 20, 1959.
313. *Binghamton (NY) Press*, March 6, 1959.
314. *Burlington Weekly Free Press*, February 16, 1959.
315. *Toledo (OH) Blade*, April 15, 1959.
316. Champion, *Alcatraz Unchained*.

A Terrible Scandal (1960-1969)

317. *Ninety-sixth Annual Report City of Burlington, Vermont, for the Year Ending June 30, 1961* (Burlington, VT: Free Press Printing Co., 1962).
318. *Burlington Weekly Free Press*, January 6, 1962.
319. Michael Miller, *Deep Nights: A True Tale of Love, Lust, Crime and Corruption in the Mile High City* (n.p.: AuthorHouse, 2010).
320. *Life* 52, no. 20 (May 18, 1962).
321. *Burlington Weekly Free Press*, January 6, 1962.
322. Ibid., January 13, 1962.
323. Ibid., January 15, 1962.
324. Ibid., January 16, 1962.
325. Ibid., January 13, 1962.
326. Ibid., January 16, 1962.
327. Ibid., March 23, 1962.
328. Ibid.
329. Ibid., March 29, 1962.
330. Ibid., April 2, 1962.
331. Ibid., April 7, 1962.
332. *Ninety-eighth Annual Report City of Burlington, Vermont, for the Year Ended June 30, 1963* (Burlington, VT: Free Press Printing Co., 1964).
333. Ibid.
334. Ibid.
335. *Ninety-ninth Annual Report City of Burlington, Vermont, 1964, for the Year Ended June 30, 1964* (Burlington, VT: Free Press Printing Co., 1965).
336. *One Hundred and Second Annual Report City of Burlington, Vermont, 1967, for the Year Ended June 30, 1967* (Burlington, VT: Free Press Printing Co., 1968).
337. *Bennington (VT) Banner*, May 22, 1971.
338. *Burlington Free Press*, March 22, 1967.
339. Ibid., March 24, 1967.
340. Ibid.
341. Ibid.
342. Ibid.
343. Ibid.
344. *One Hundred and Fourth Annual Report City of Burlington, Vermont, 1969 for the Year Ending June 30, 1969* (Burlington, VT: Free Press Printing Co., 1970).

Murder in the Queen City (1970-1979)

345. Stuart Perry, "Police Question Area's Known Sex Offenders," *Burlington Free Press*, July 22, 1971.
346. Ibid.
347. Stuart Perry, "Police Check 'Peeping Tom' Reports in Area Where Girl Was Murdered," *Burlington Free Press*, July 23, 1971.
348. *Burlington Free Press*, May 29, 1979.
349. *(Troy, NY) Times Record*, July 11, 1973.
350. *Bennington (VT) Banner*, March 12, 1974, 3.
351. Ibid., March 13, 1974.
352. Ibid., October 1, 1973.
353. Ibid., October 2, 1973.
354. Ibid., April 18, 1974.
355. Ibid., May 2, 1975.
356. Ibid., January 13, 1976.
357. Ibid., February 2, 1976.
358. *Portsmouth (NH) Herald*, March 2, 1976.
359. Duffy, Hand and Orth, *Vermont Encyclopedia*, 77.
360. *Bennington (VT) Banner*, August 4, 1976, 5.
361. Ibid.
362. Ibid.
363. Ibid.
364. *Burlington Free Press*, March 12, 2011.
365. *Bennington (VT) Banner*, November 27, 1974, 7.
366. Ibid., July 24, 1975, 9.
367. Ibid., October 8, 1975.
368. *Burlington Free Press*, October 8, 1975.
369. Ibid.
370. Carlo Wolff, "Abare Is Named Interim Chief of Police," *Burlington Free Press*, October 10, 1975.
371. William Ringle, "Violent Crime at Record Height," *Burlington Free Press*, March 25, 1976.
372. John Donnelly, "Battery Park Police, Youths Clash," *Burlington Free Press*, July 1, 1979.
373. Ibid.
374. Ibid.
375. *Burlington Free Press*, July 2, 1979.
376. Ibid.

377. Ibid.
378. Ibid.
379. Mike Donoghue and Alan Abbey, "Police, Youths Clash Again at Battery Park," *Burlington Free Press*, July 3, 1979.
380. Ibid.
381. Ibid.
382. John Donnelly, "Battery Park 'Riot' Justified Arrests, Officials Say," *Burlington Free Press*, July 5, 1979.

Politics, Drugs and Mass Arrests (1980-1989)

383. John Donnelly, "Paquette Says He May Suggest Police Layoffs," *Burlington Free Press*, June 30, 1979.
384. Fran Brock, "Woman Attacked Downtown," *Burlington Free Press*, July 18, 1980.
385. Mark Johnson, "Police Chief Burke: Reinstate the Death Penalty," *Burlington Free Press*, October 30, 1985.
386. *Burlington Free Press*, May 9, 1985.
387. Ibid.
388. Ibid., June 27, 1985.
389. Ibid.
390. City of Burlington, Vermont, 1986 Annual Report, July 1, 1985–June 30, 1986.
391. Mark Johnson, "Chief Burke Resigns Scully Named to Head Burlington Police," *Burlington Free Press*, January 30, 1986
392. Melissa Birks, "Former City Chief of Police, Donald Russell, Dies Friday," *Burlington Free Press*, July 25, 1987.
393. Enrique Corredera, "Pomerleau Resigns as Police Commission Chief," *Burlington Free Press*, September 15, 1987.
394. Judith Shuleyitz, "Criminal Justice Funds Cut Back," *Burlington Free Press*, January 8, 1988.
395. Ian Polumbaum, "City Officers Blame Stress, Workload for High Turnover," *Burlington Free Press*, February 21, 1989.
396. Ted Tedford, "Police Cart Off 97 Abortion Protestors," *Burlington Free Press*, November 30, 1988.
397. Diane Derby, "Kryptonite Inadvertently Linked to Issue," *Burlington Free Press*, May 16, 1990.

Recent Decades (1990-2015)

398. Lori Campbell, "Police Incensed Over Bond Vote," *Burlington Free Press*, November 9, 1990.
399. Susan Kelley, "Violent Crime Rattles Residents of Old North End," *Burlington Free Press*, May 26, 1992.
400. Ibid.
401. Andrea Zentz, "Vermont Heroin Use on the Rise," *Burlington Free Press*, May 3, 1993.
402. *Burlington Free Press*, November 4, 1993.
403. Aki Soga, "Developer Buys Land for Police," *Burlington Free Press*, April 2, 1994.
404. *Burlington Free Press*, May 1, 1998.
405. Tamara Lush, "New City Police Chief Takes Oath," *Burlington Free Press*, December 5, 1998.
406. Tamara Lush, "Chief Embraces City's Challenges," *Burlington Free Press*, December 7, 1998.
407. *City of Burlington, Vt. Annual Financial Report for the Year Ending June 30, 2003.*
408. *City of Burlington, Vt. Annual Financial Report for the Year Ending June 30, 2004.*
409. *City of Burlington, Vt. Annual Financial Report for the Year Ending June 30, 2006.*
410. *City of Burlington, Vt. Annual Financial Report of the Year Ending June 30, 2007.*
411. Ken Picard, "Burlington PD's Computer System Was Clunky and Costly—So Chief Mike Schirling Built a New One," *(Burlington, VT) Seven Days*, October 24, 2012.
412. *City of Burlington, Vt. Annual Financial Report of the Year Ending June 30, 2014.*

INDEX

A

Abare, Robert 153
Adams, John R. 133, 134
Adsit, Elbridge S. 41
Aiken, George 110, 111
Allen, James 68
Austin, N.E.L. 71–72, 73, 77, 86, 92, 94, 105

B

Ballou, Phineas D. 34
Bancroft, Gloria 139, 152–153
Bank Street 55, 117
Barton, Joseph 40, 41–42
Bates, Richard D. 134
Battery Park 82, 154, 155, 156
Battery Park Riot 154–156, 164
Beaulieu, Richard 139, 152–153, 157
Bedard, Henry 78–79
Bee, May 74–75
Bergeron, Dolor H. 124
Bigelow, Walter J. 62–63
Billings, Franklin S. 86
Bing, Robert K. 133, 135, 136
Bishop DeGoesbriand Hospital 109
Black Mariah 80
Blair, Francis 120
Bleau, William J., Jr. 134
Blodgett, Calvin H. 36
board of aldermen 42, 57, 62, 70
board of medical examiners 104
board of police examiners 45, 57, 62
Bousquet, Henry E. 79, 95, 96, 106
Bradley, Kevin 150–152
Brewer Motors shooting 140–143
Brookes Avenue 79, 145
Brothers, John J. 61
Brownell, Edward F. 54, 55, 57–58
Bundy, Theodore "Ted" 145
Burke, James E. 56–58, 62–63, 65, 69–70, 98–99, 101, 116
Burke, John (alias William Karpensky) 100, 101
Burke, William 157–159
Burns, John J. 110, 114, 116
Byrnes, Thomas 44

C

Carlson, Wayne 147–149
Carron, Arthur J. 115, 125, 133, 135, 136, 137, 141, 143, 150, 152, 164

INDEX

Cathedral of the Immaculate Conception 84
Center Street 118
Chittenden County Jail 21, 74
Church Street 26, 51, 52, 67, 81, 85, 86, 87, 90–92, 103, 119
city hall 35, 36, 37, 40, 48, 51, 52, 63, 86, 101, 103, 111, 129, 159
City Hall Park 21, 22, 82, 102, 150, 151
Clavelle, Peter 166
Clymer Street 73, 74
Coffey, William G. 51
Colchester Avenue 79
College Street 66, 98, 102
Collins, William G. 63, 73, 78
Coon, Edward R. 51–52
Corbett, William W. 115
Cosgrove, Patrick J. 49, 51, 61, 97, 98, 99, 101–102, 117
Costello, Edward J. 134, 140
Couture, Leonard P. 115
Cowles, C.P. 85
Croll, William G. 124
Crombie, William A. 42
Curran, Rita
 homicide 145–146

D

Daley, Edward T. 73–74
Davis, Donald P. 150
Delaney, J.M. 61
Delisle, Albert 82
Delorme, Bruce 140
Demag, David 154
Demag, Donald E. 119–120, 150, 151
Detective Bureau 136, 150, 152, 153, 160
Dillinger, John 99
Dimick, Paul E. 101
Dow, Louis 101, 104, 106, 107
Drew, Luman A. 27–28, 33, 34, 35–38, 39
Dubrul, Fedora 115
Dumas, Jerome 41, 42, 44, 45, 46, 47, 48

E

Ennis, Alana 164, 165
Ethan Allen Fire House 86
Ethan Allen Tower 44

F

Farmer, Gilbert 53–54
Fassett, John, Jr. 21
Fisher, J. Albert 117–118, 130
Fisher, Victor 97, 98, 102–105, 118, 124
Fish, Frank L. 90
Flanagan, Noble B. 29, 31, 32, 33, 34, 35
Flying Bank Robber 130–131
Fondry, Gladys 83, 84
Francis, John H. 94

G

Gamewell System 58, 59, 62, 103
Gardner, Myer 100, 108, 115
Garrow, William W. 61
Gillis, Father 59, 68, 84
Gorman, James W. 68
Graton, Milo C. 51
Great Flood of 1927 92
Griswold murder case 29–35
Grout, Aaron H. 101
Gutchell, Albert J. 79, 90, 94

H

Harrington, John J. 101, 102, 116
Haselton, Seneca 43, 61, 62
Hatch, Jo D. 36, 37, 39
Hawley, D.C. 56
Hayes, James E. 128
Heed, Beatrice 90–92
Heed, Philip 90–92
Henry, William W. 41–42
Hines, Louis 157
Homes, Dr. Henry H. 46–49
Hoover, J. Edgar 95, 108, 113
Horton, Edward 61
Horton, Ezra M. 85, 86

INDEX

I

Identification Bureau 96, 106, 107
Intervale 89, 90
Investigation Bureau 107
Isham Street 79, 128

J

Jackson, J. Holmes 70, 81, 95
Jerry, William 86
Johns, Mabel 115

K

Karpowich, George 115
Kendrew, Dennis 89
King, John 147
Ku Klux Klan Burglary 84–86

L

Labarge, Joachim 59, 61
Ladd, Jed P. 75
Lafountain Street 53
Lake Champlain 19, 29, 42, 44, 51, 77
Lake View Sanitarium 77
Lakeview Terrace 109, 110
LaPierre, Henry 88, 90
Larney, John "Molly Matches" 44–45
LaRose, Joseph A. 40–41
Larr, Bernard (alias Frank Lupcwicz) 100, 101
Lavalee, Francis 59–60, 61
Lavery, Frank J. 110
Lawrence, Paul 150–152
Leahy, Patrick J. 141, 150
Lesage, Bernadette 157
Liberty, Wayne 137
Limoge, Arthur J. 80, 84, 85
Linsley, D.C. 35
Lyman, Elias 67
Lynch, Peter 66

M

Main Street 59, 60, 83, 85, 88, 101, 117, 124
Malaney, Howard W. 115
Malloy, John J. 133, 134
Mansfield Avenue 78, 79, 161
Maple Street 102
Marengo, Edward 61
marijuana 110
Martin, Jed 83, 84
Mary Fletcher Hospital 63
McCarty, Frank J. 100
McCreedy, William 85
McCuen, Geary 140
McCully, Edith 71
McElligott, Edward P. 41, 51
McGaughan, Frank S. 78
McGettrick, Edward 67
McGowan, James 84
McGrath, James P. 59–62, 130
McKenzie, George 124, 126, 134–136
McNeil, Joseph C. 126
McSweeney, Dr. P.E. 59, 83, 84
Medler, Frank J. 94
Mercure, Raymond B. 115
Miles, Christopher 67–69, 73
Miles, Harold 147
Monette, Fred 74–75
Moody, Florence 82
Mooney, Harvey F. 72–73
Moran, J. Edward 121, 128
Morse, George H. 40
Moulton, Sherman R. 92
Mount Saint Mary's Academy 78
Moyers, William 85–86
Muir, Harry J., Jr. 134
Murray Street 68
Myatt, George 60
Myers Viola
 shooting 109–110

INDEX

N

North Avenue 108, 109, 140, 142, 161, 164
North Champlain Street 59, 92
North Prospect Street 79, 109
Northrop, Consuelo 87
North Street 92, 105, 107, 119
North Willard Street 79
North Winooski Avenue 46–47, 107

O

Old North End 68, 109, 159, 163

P

Paquette, Gordon H. 154, 156
Peck, Hamilton S. 48, 49, 56
Pecor, Kenneth "Red" 153
Peeters, Loretta 83, 84
Peeters, Pauline 83, 84
Perrigo, Wilbur E. 40–41
Perry, Dewey 89
Pine Street 102, 124
Pinto, Vincent (alias Vincent Aleska) 100, 101
Ploof, Joseph 67–69
police ambulance 78, 90, 128
police matron 71, 73, 77, 105
police motorcycles 79, 103
police motorcycle unit 80
Pomerleau, Antonio 154, 160, 164
Prohibition 55, 73, 80–82
Provost, Robert W. 128, 130

R

Racicot, Francis
 murder 118–120
radio 105, 108, 137
Raymond, Frank G. 114, 115, 120
Reeves, Thomas 49, 52, 54
Regen, Francis S. 104, 106
Reindeer, the 49–50, 52
Roberts, Robert 53, 54
Rock, Joseph T. 100

Rodriguez, Luis "Ponce" 152
Rouille, John 137
Rowell, Honorable John W. 49
Rudolph family
 David 138, 140
 Jacqueline 139, 140
 murders 138–140
 Rodney 139, 140
Rugg, Hazel 73–74
Russell, Donald P. 121, 126, 127, 130, 134, 160
Russell, Julius 51, 52
Russell, Patrick J. 58–61, 65, 72, 74, 78–80, 86, 87, 97, 121
Russell, Thomas J. 115
Ryan, John H. 55, 61, 63–64, 68, 78, 97

S

Saint Paul Street 84
Salmon, Thomas P. 149
Sanders, Bernie 158–159
Sandy Lane 147
Scandal of 1961 133–138, 150
Schirling, Michael 168
School Street 72
Schwartz, Michael F. 150–151
Scott, James "Bucky" 131, 137
Scully, Kevin P. 159–160, 164
Shappy, Edward 109–110
Shelburne Road 73
Sinon, George W. 75, 78, 84
Sleuth (station cat) 98
Smith, Loomis J. 48–49, 51, 52, 53–54
South Winooski Avenue 56, 63, 66, 98, 117, 134, 137, 138, 142, 163
Splain, John J. 72
Sprenz, Frank 130–131
state prison at Windsor 86, 110, 119
St. Joseph's cemetery 61, 88, 116
St. Mary's Cathedral 61
Sutton, Elliot 48, 49, 51, 52–53, 54
Symmonds, Wilmer 88–90

INDEX

T

Thalacker, Arthur W. 107–108, 110, 113, 121, 124
third degree 61
Tierney, James 105
Todd, Henry 66, 88–90
Tremblay, Thomas R. 166

U

University of Vermont 22, 32, 47
University of Vermont Riot 65–67
UVM Lingerie Raid of 1952 126–128

V

Van Ness Hotel fire 124–126
Van Patten, William J. 43–44
Vergennes, VT 60, 139
Vilas, Martin S. 101
Vincent, Joseph F. 66, 79, 88–89, 94
Vincent, Levi 94

W

Wales, Torrey E. 32–33, 35
Wallace brothers (John and Charles) 50–52
Ward, John 29–32
Ward Street 67
Waterbury State Hospital 61, 68, 110, 140
Wells, Gordon 85
West, Charles 128
Weston, Clarence E. 94
Williams, Benjamin 61–62
Willis, Agnes 53–54
Winooski River 86, 90, 92
Winooski, VT 29, 31, 67, 91, 130
Woodbury, Urban A. 124

ABOUT THE AUTHOR

Jeffrey H. Beerworth lives in northern Vermont with his wife and four children. He graduated from the Montserrat College of Art in 2003, having studied painting and art history. He has worked as a police officer with the Burlington Police Department since 2007 and is currently assigned to the Detective Bureau. His love of history and interest in how social, cultural and political issues impact police work in Burlington have led him to write this book in commemoration of the 150th anniversary of the Burlington Police Department.

Visit us at
www.historypress.net

This title is also available as an e-book